D1413804

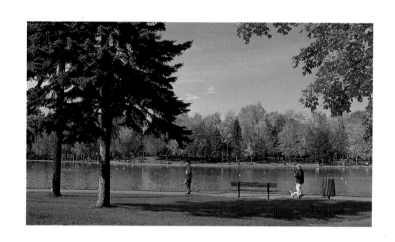

MONTREAL

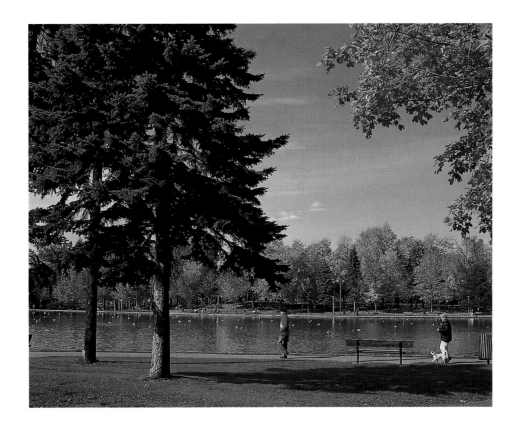

WHITECAP BOOKS
VANCOUVER / TORONTO

Edited by Elizabeth McLean
Proofread by Lisa Collins
Cover and interior design by Steve Penner
Cover photograph by Y. Marcoux / Publiphoto
Typesetting by Tanya Lloyd
Printed and bound in Canada

Canadian Cataloguing in Publication Data

Lloyd, Tanya, 1973–
 Montreal

 ISBN 1-55110-753-8

 1. Montréal (Quebec)—Pictorial works. I. Title.
FC2947.37.L66 1998 971.4'2804'0222 C98-910014-6
F1054.5.M843L56 1998

The publisher acknowledges the support of the Canada Council and the
Cultural Services Branch of the Government of British Columbia in making this
publication possible. We acknowledge the financial support of the Government
of Canada through the Book Publishing Industry Development Program for our
publishing activities.

For more information on the Canada series and other Whitecap Books
titles, please visit our web site at www.whitecap.ca.

Montreal has an allure no other Canadian city can match. It spills from the outdoor cafés, where lovers, students, and visitors blend in a scene reminiscent of Paris. It echoes in the sound of hooves as a calèche—a horse-drawn carriage—carries sightseers through Mount Royal Park. It lies in the early morning quiet of Old Montreal's cobblestoned squares.

The city has undergone many rebirths in its long history. It began as an Iroquois village. In fact, more than 1000 First Nations people lived here when explorer Jacques Cartier arrived in 1535. In the 17th century, the island was a major fur trading centre. It soon became a base for Roman Catholic missionaries when a small group of settlers established Ville-Marie in 1642. In each of its incarnations, Montreal's location on the St. Lawrence has made it a natural centre for communication and commerce.

In 1760, the British conquered New France and created an intense juxtaposition of language and culture that has never faded. Lawyer and poet F. R. Scott once said, "There are two miracles in Canadian history. The first is the survival of French Canada, and the second is the survival of Canada." Montreal has not only survived, it has prospered. The city celebrated its 350th anniversary in 1992. Today, it is the second largest French-speaking city in the world and boasts North America's largest inland port.

Throughout Quebec's sovereignty debates, language questions, and cultural revolutions Montreal has lost none of its joie de vivre. During its many festivals, from the Snow Festival and the International Jazz Festival to Just For Laughs and the annual film festival, a spirit of celebration permeates the city. And small signs of charm and fun—the splash of bright violet paint on a row of grey homes, the honeyed sweetness of a bagel, or the extravagant costume of a street performer—make every day in Montreal an exuberant expression of life.

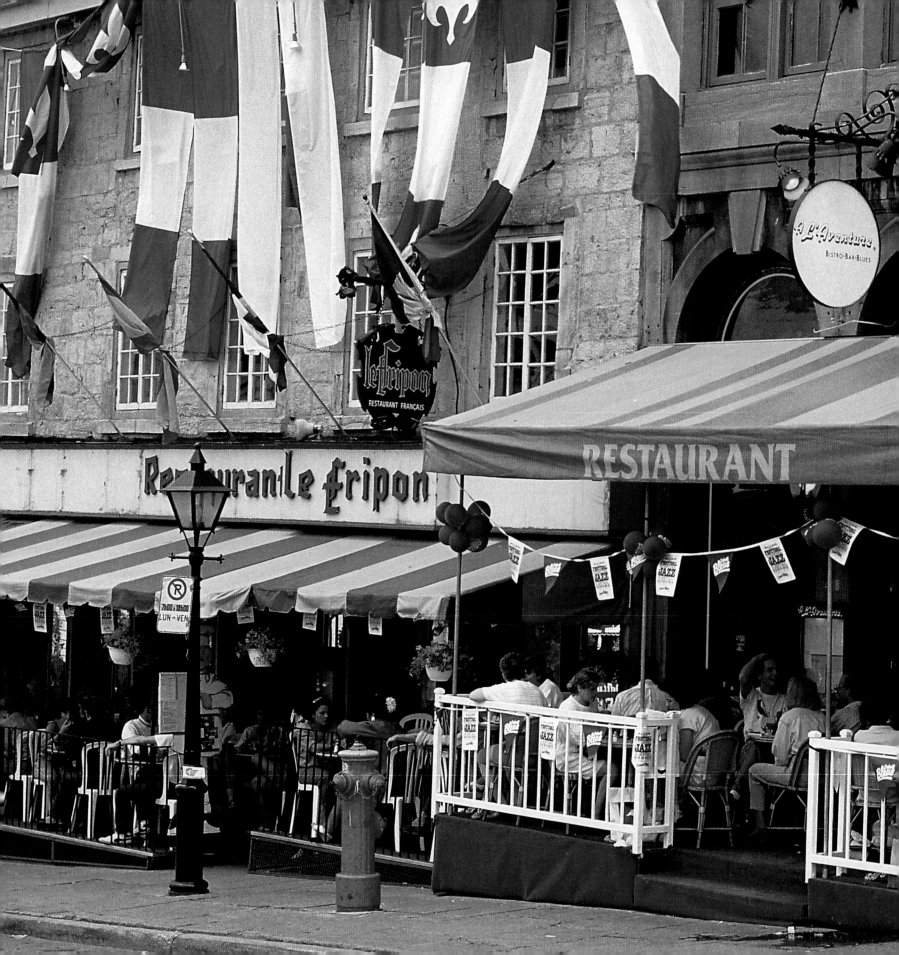

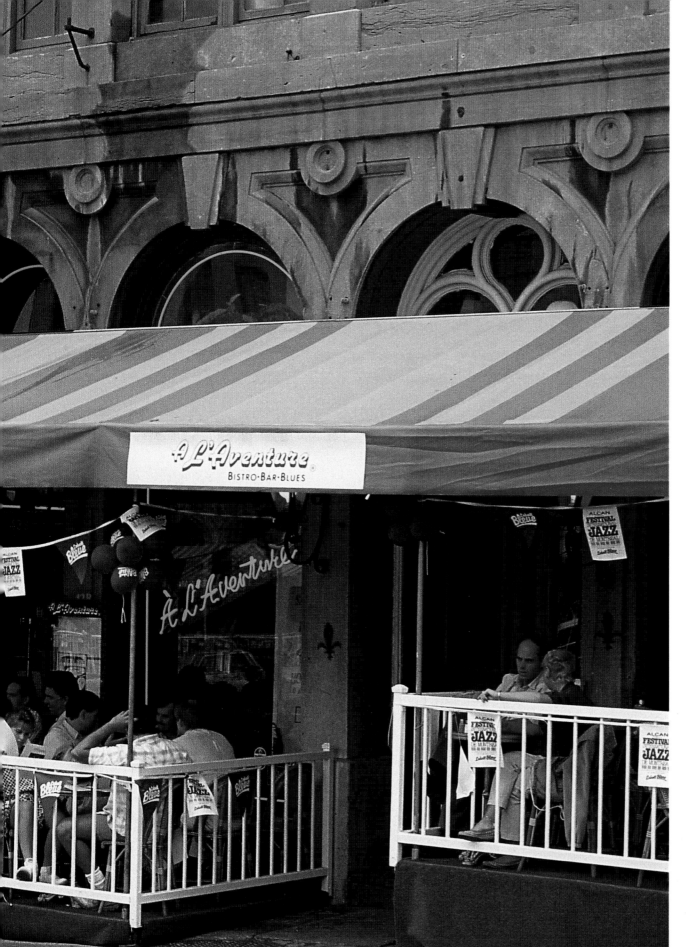

Montreal is a diner's paradise, with more than 4000 restaurants. Visitors to Montreal's outdoor cafés, such as this sunny spot in Old Montreal, will find the tables filled with businesspeople, shoppers, and students enjoying an afternoon break.

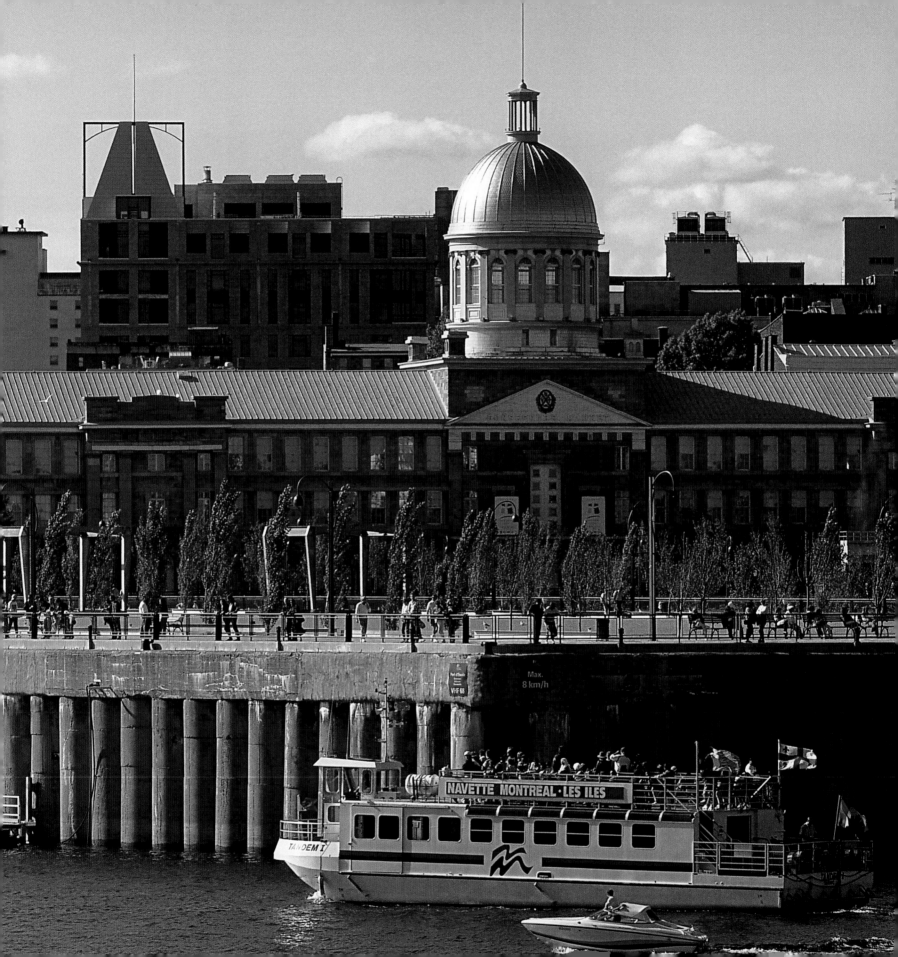

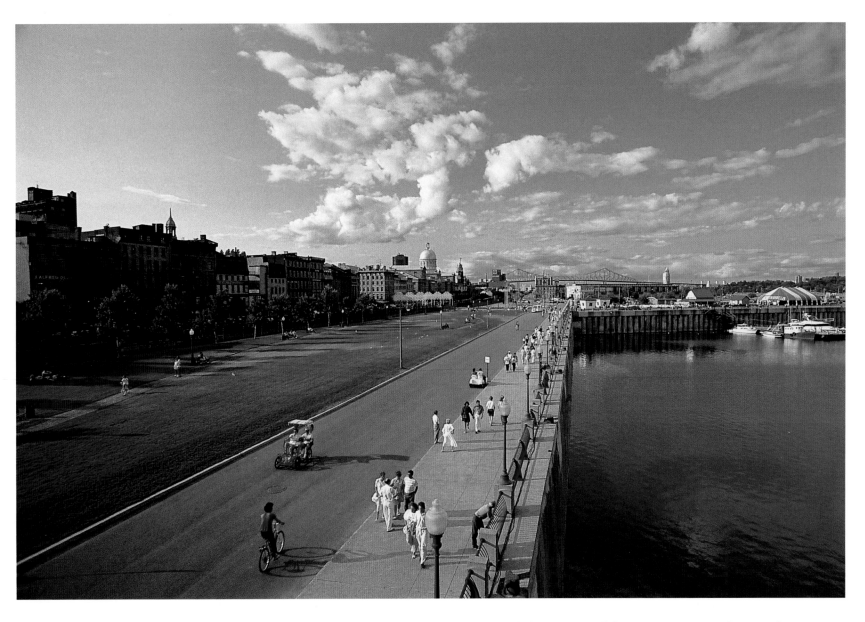

The two-kilometre Old Port promenade is a favourite escape for cyclists, joggers, and in-line skaters.

The creation of pedestrian walkways and parkland in the Old Port has allowed visitors a clear view of the St. Lawrence River. The view had been blocked by industrial developments for most of the previous two centuries.

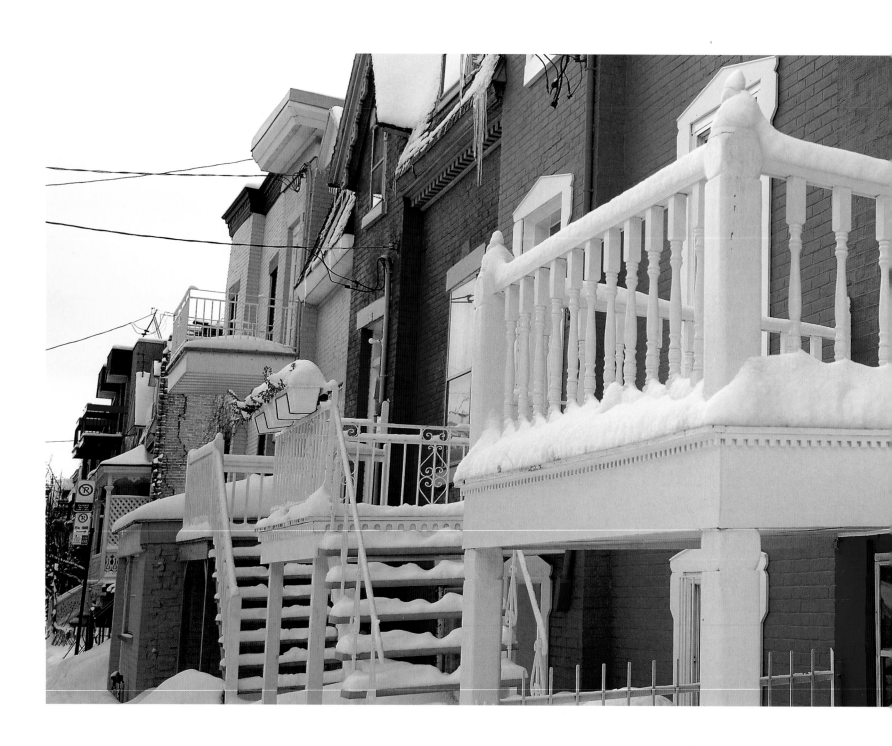

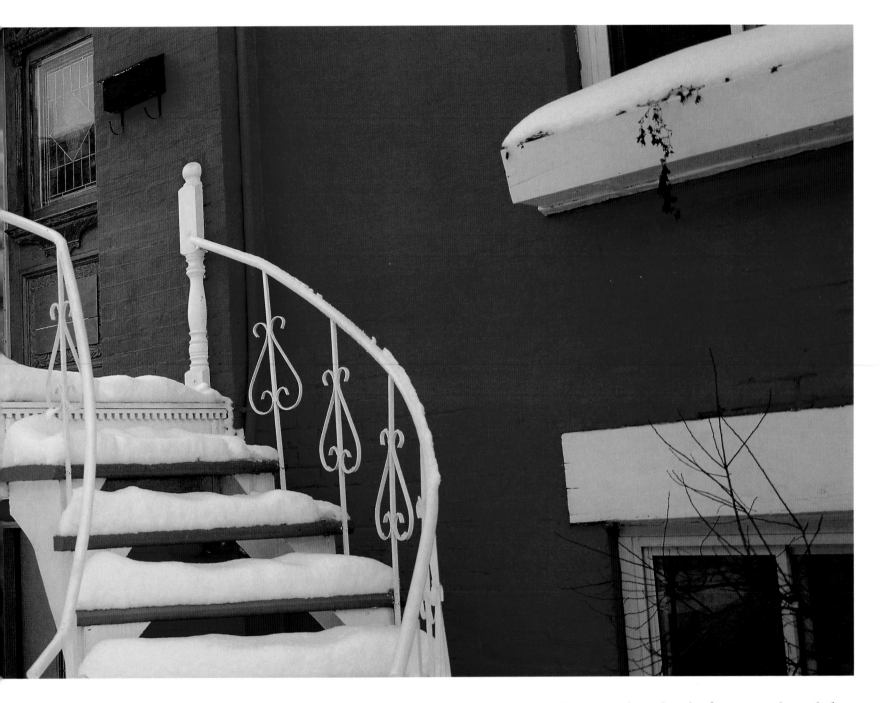

There are 28 municipalities on the island of Montreal, and the neighbourhoods of each have a slightly different character.

For more than 300 years, activity in Montreal was focused along the St. Lawrence River in what is now Old Montreal. In the early 1900s, businesses began to move closer to Mount Royal, towards the city's present downtown district. Old Montreal was the site of a massive restoration effort in the 1960s, when local businesses and the government joined forces to save the historic buildings and charming cobblestoned squares.

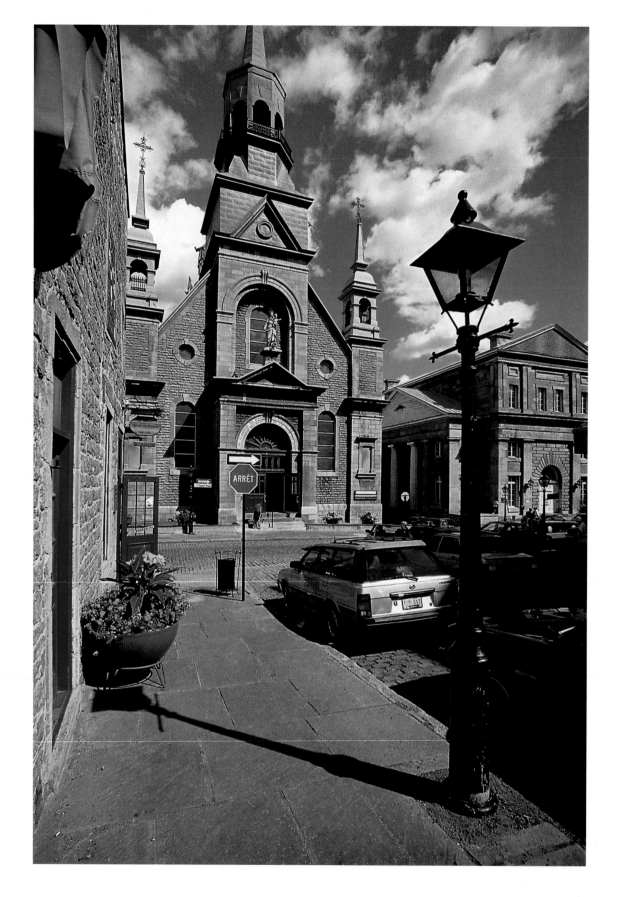

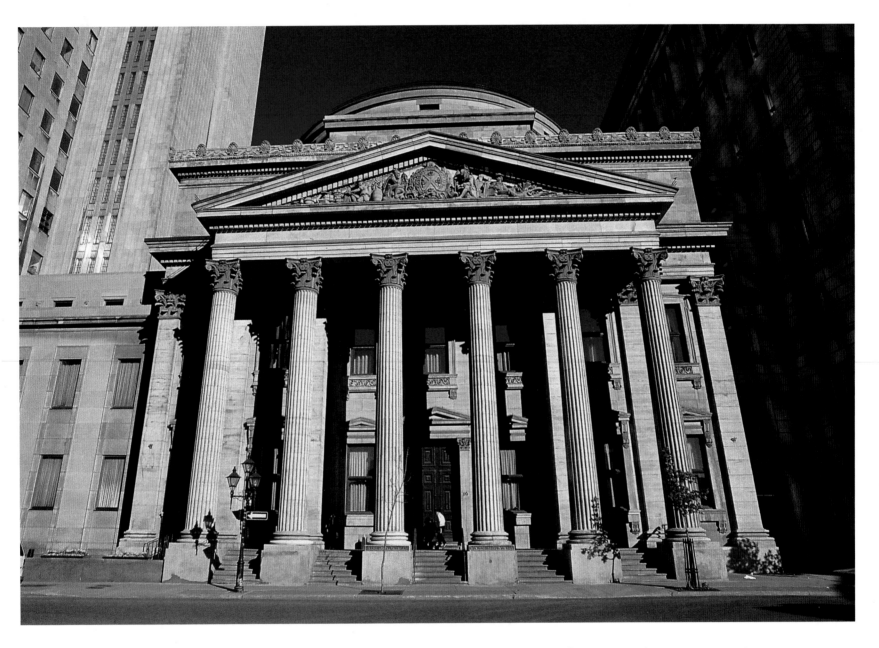

The Bank of Montreal is Canada's oldest bank. In 1818, the organization built the first Canadian bank building. This newer building, still part of the bank's head offices, was designed by John Wells in 1847.

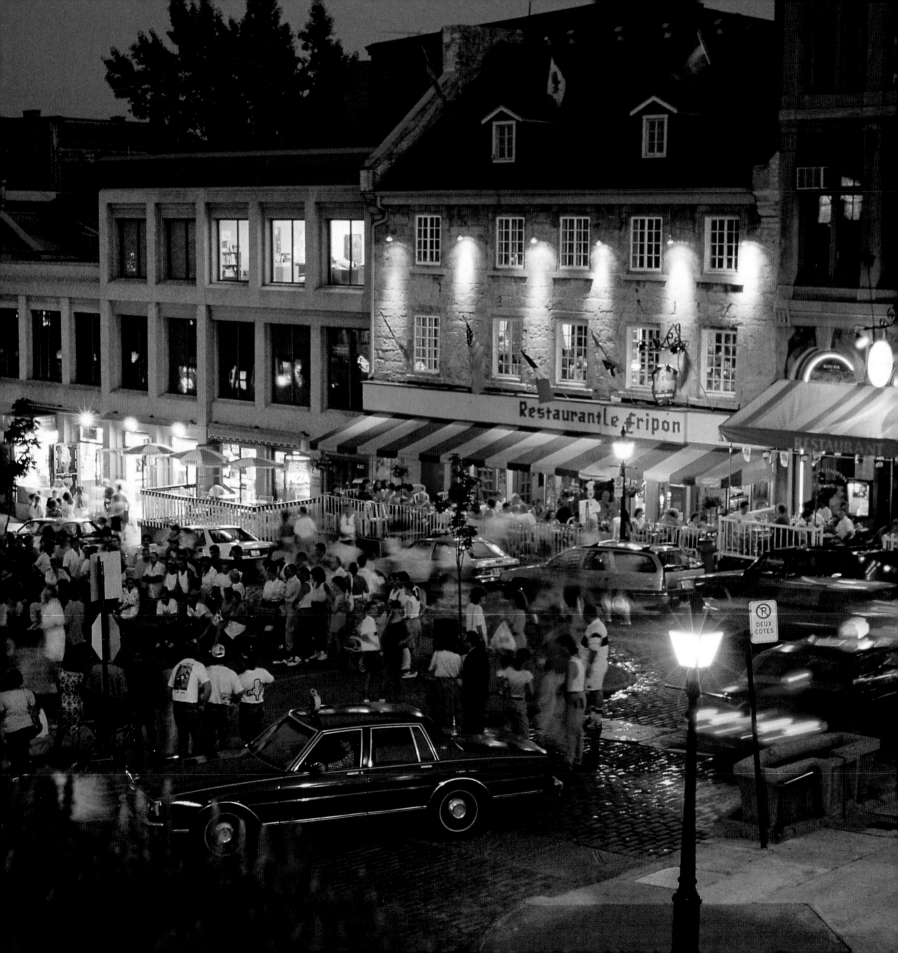

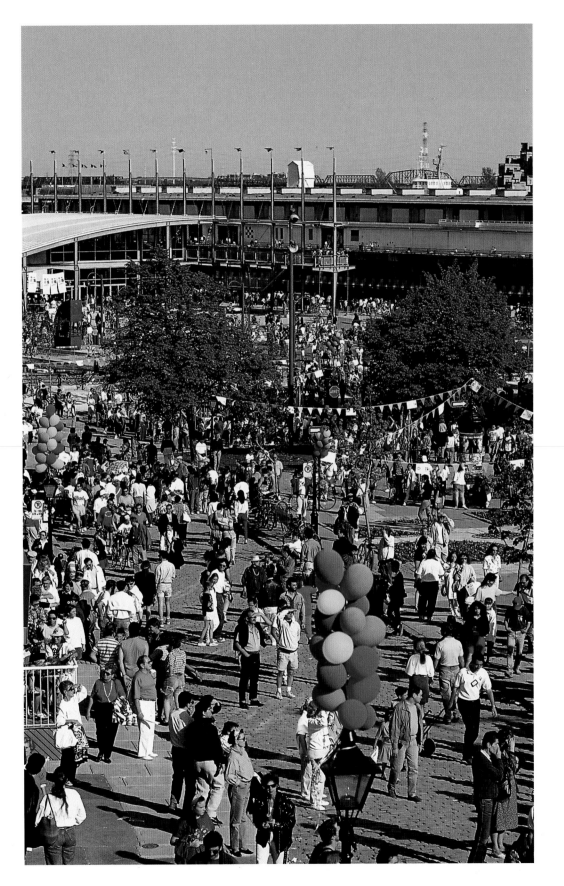

Place Jacques-Cartier was once part of the Marquis de Vaudreuil's estate. When the house burned down in 1803, the land was bought by local merchants and this square was given to the city for the creation of a public market.

FACING PAGE— The cobblestoned Place Jacques-Cartier was an outdoor market until the early 20th century. Now lined with stores and restaurants, it still serves as a flower market in the summer.

15

Named after Claude de Ramezay, a governor of Montreal in the early 1700s, Château Ramezay was the traditional home of French governors in the city. It was once temporarily home to Benjamin Franklin, as American troops attempted an invasion in 1775. The building now houses a museum celebrating local and provincial history.

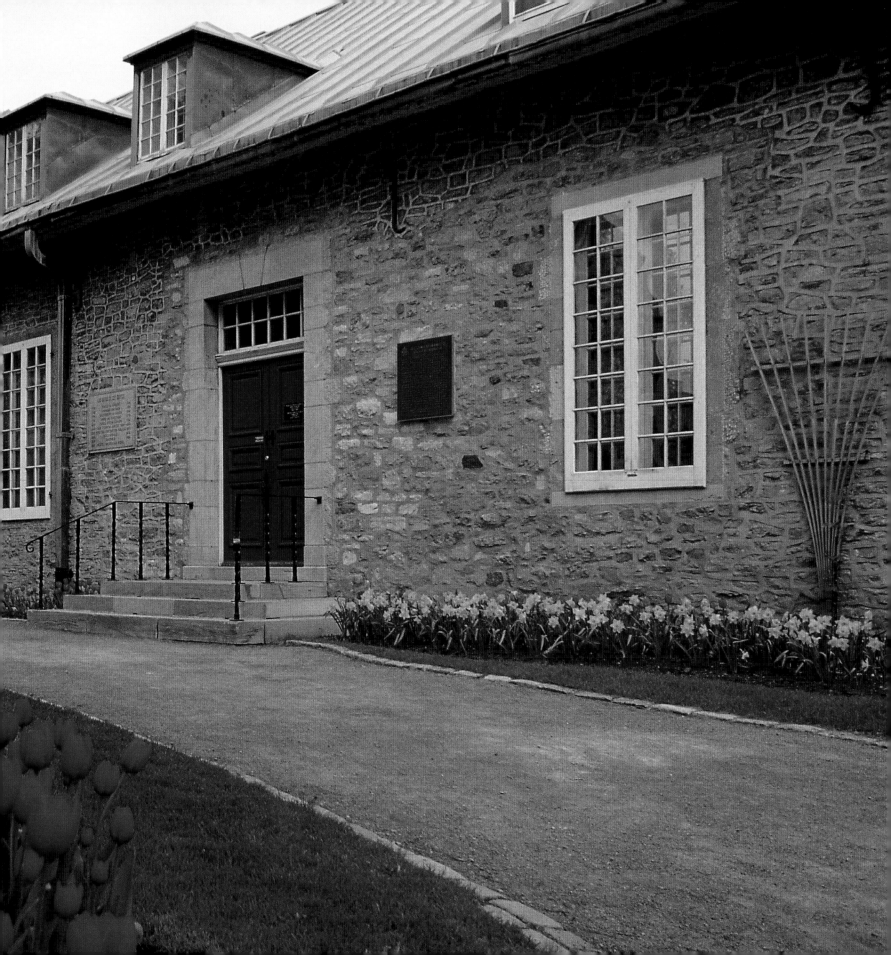

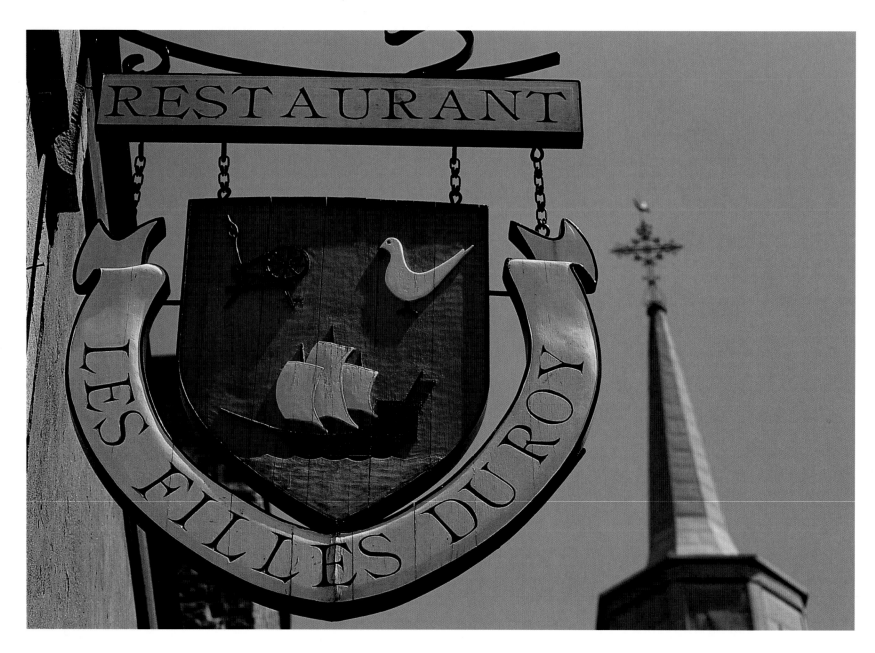

Les Filles du Roy, one of Montreal's most renowned restaurants, hosted guests from Mick Jagger to Princess Grace of Monaco. It closed in 1992, and the building is now part of the historic La Maison Pierre-du-Calvet, a heritage home with a café and accommodations open to visitors.

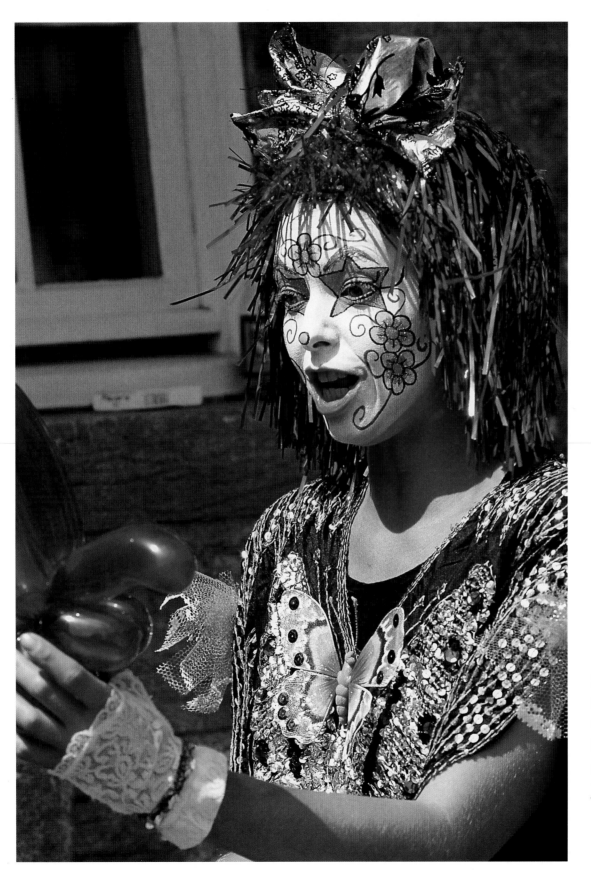

Street entertainers such as this brightly costumed clown brighten summer afternoons in Place Jacques-Cartier.

Notre Dame Basilica houses the Gros Bourdon, an 11-tonne bell, as well as a 7000-pipe organ. Opened in 1829, the church seats 3800 people. Pop star Céline Dion was married here in 1994.

FACING PAGE—
There are more than 650 parks in Montreal. Some are neighbourhood islands of green space while others, such as Mount Royal Park, include woodlands, picnic areas, and walking paths.

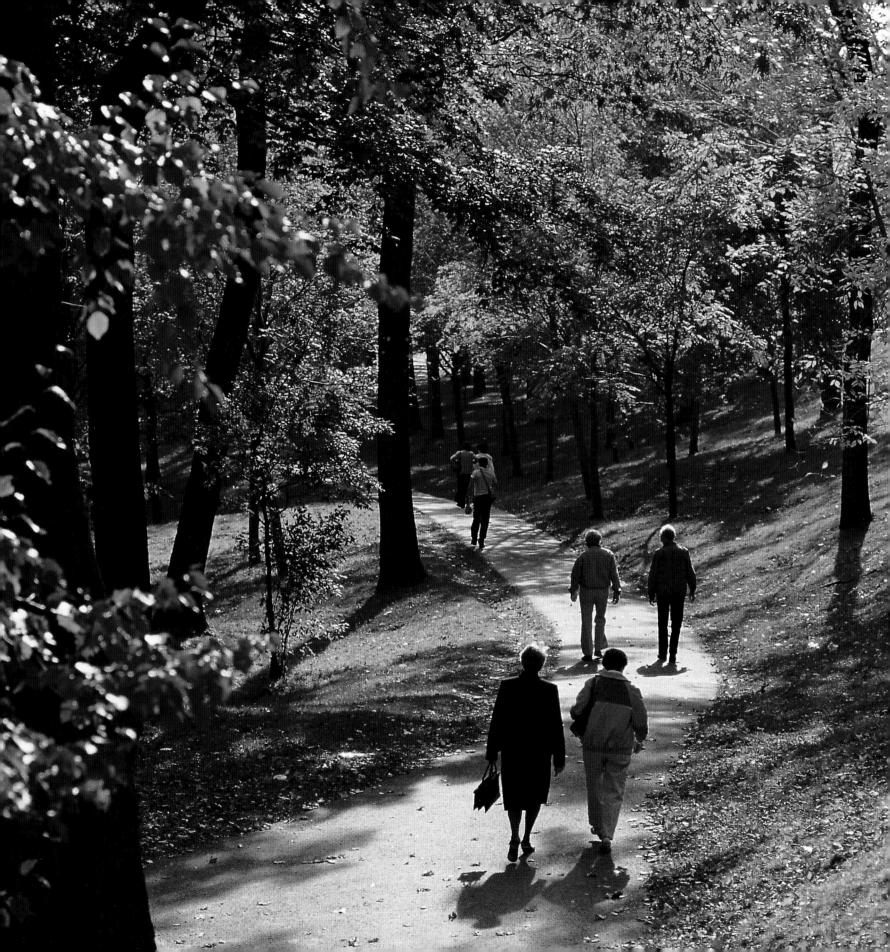

The Sulpician Seminary is Montreal's oldest building. Built in 1685, it remains home to the Sulpician order and closed to the public. The order once owned the property rights to the island of Montreal and was a political force for almost two centuries.

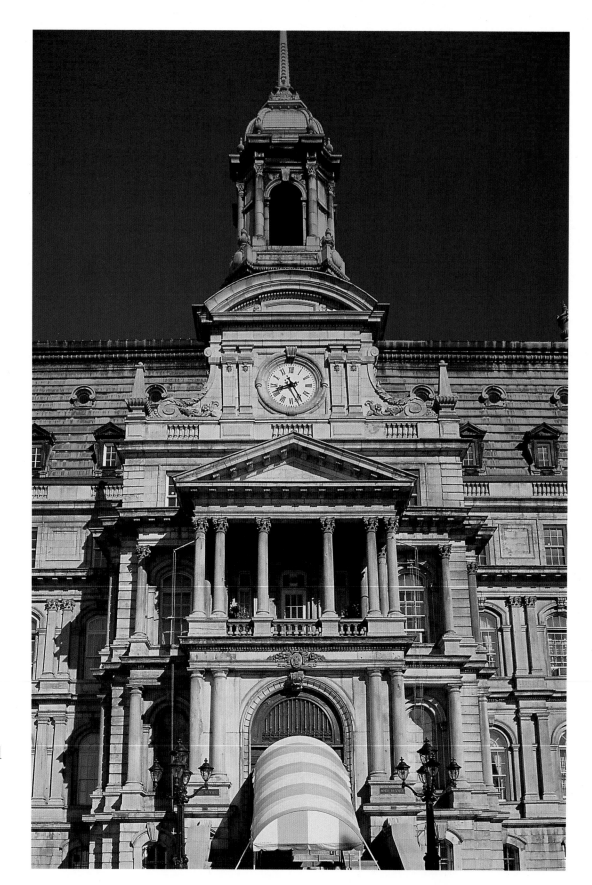

French president
Charles de Gaulle
called "Vive le
Quebec libre!" from
City Hall's balcony
in 1967. The phrase
has since symbolized
the Quebec separatist movement.

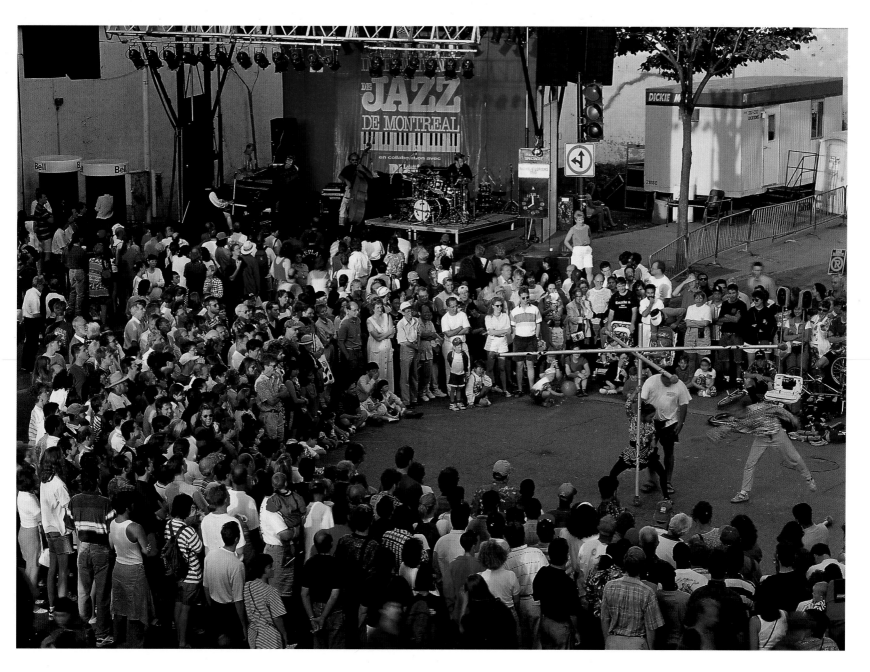

Musicians such as Miles Davis and Dizzie Gillespie have drawn crowds to the International Jazz Festival, an annual event since 1979.

Along with performances by world-renowned artists, the Jazz Festival includes hundreds of free concerts across the city. Almost 2000 musicians participate each year.

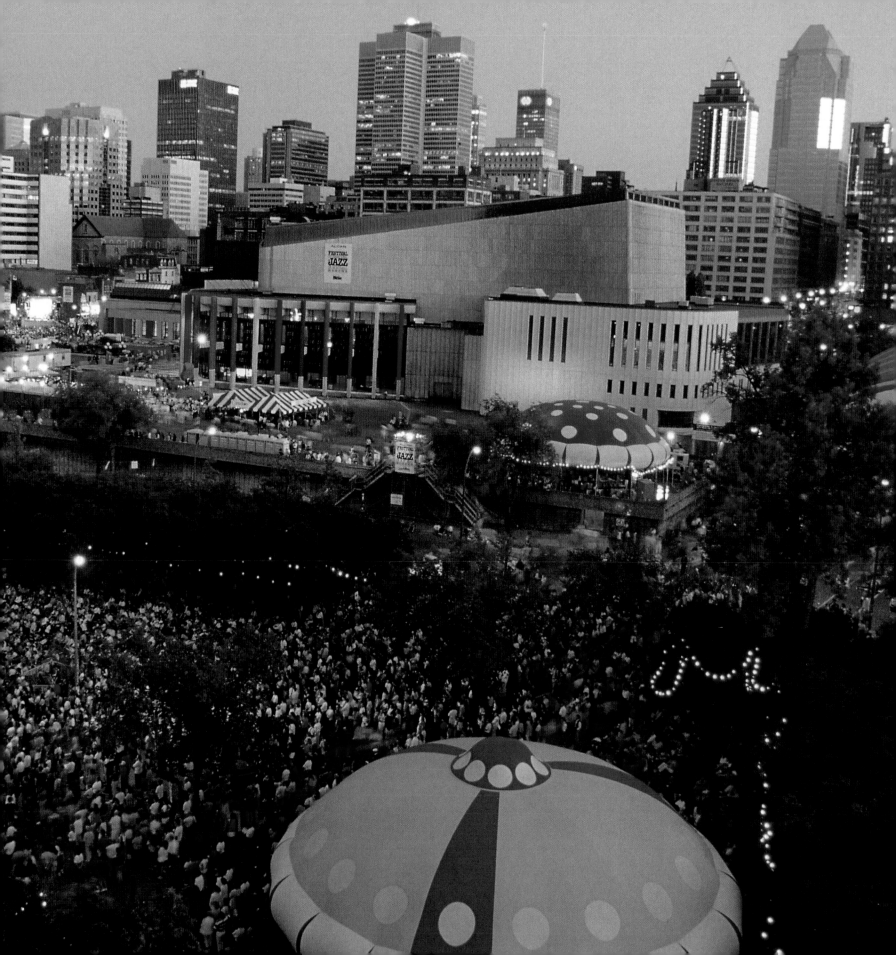

Narrow alleys past heritage homes, stone walls, and shuttered windows
are part of what makes Montreal unique. At the turn of the century, the
city's residents held 70 percent of the wealth in Canada. Although they
no longer boast that distinction, city dwellers still work to preserve
Montreal's character buildings and historic streets.

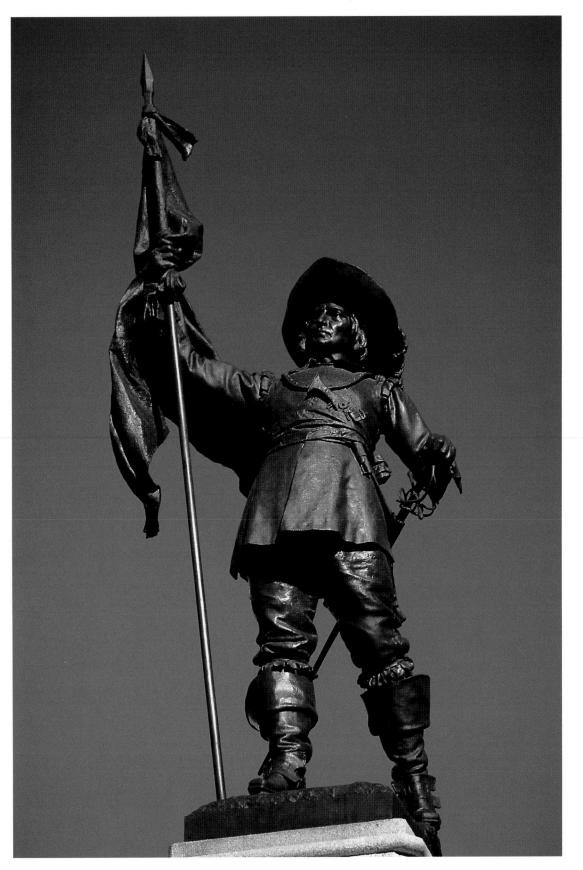

The Place d'Armes was the site of bitter battles between European settlers and the Iroquois in the 1600s. Paul de Chomedey, the founder of Montreal, was wounded here in 1644. This sculpture commemorating his life and the city's early history was carved in 1895 by Philippe Hébert.

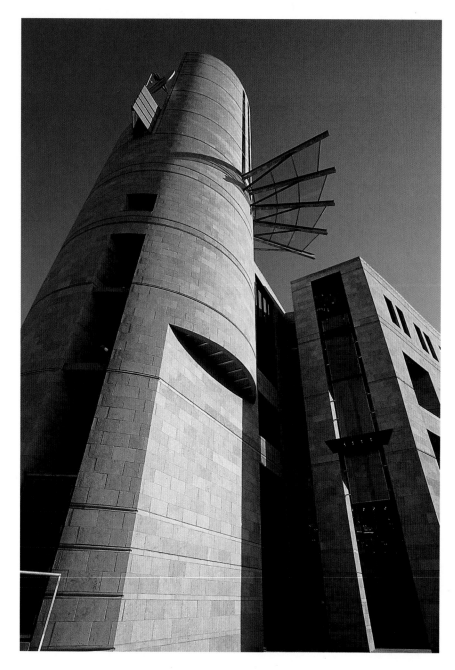

At the Pointe-à-Callière Museum of Archeology and History, visitors can wander through the excavated ruins of early Montreal. Like Quebec City, Montreal was once completely surrounded by stone ramparts. The walls were slowly destroyed to make room for the growing city.

The apartment complex Habitat was designed by architect Moshe Safdie when he was only 26. Safdie went on to design such well-known public buildings as the Vancouver Public Library and Saanich Commonwealth Place in British Columbia and the National Gallery in Ottawa, Ontario.

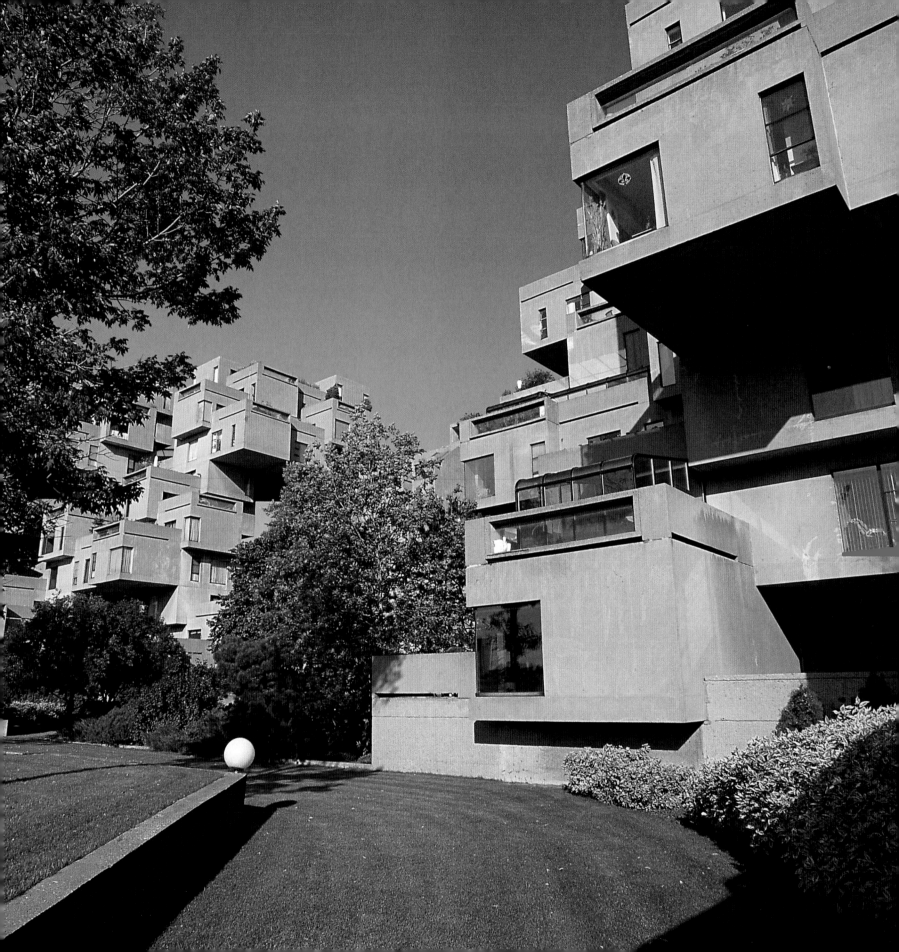

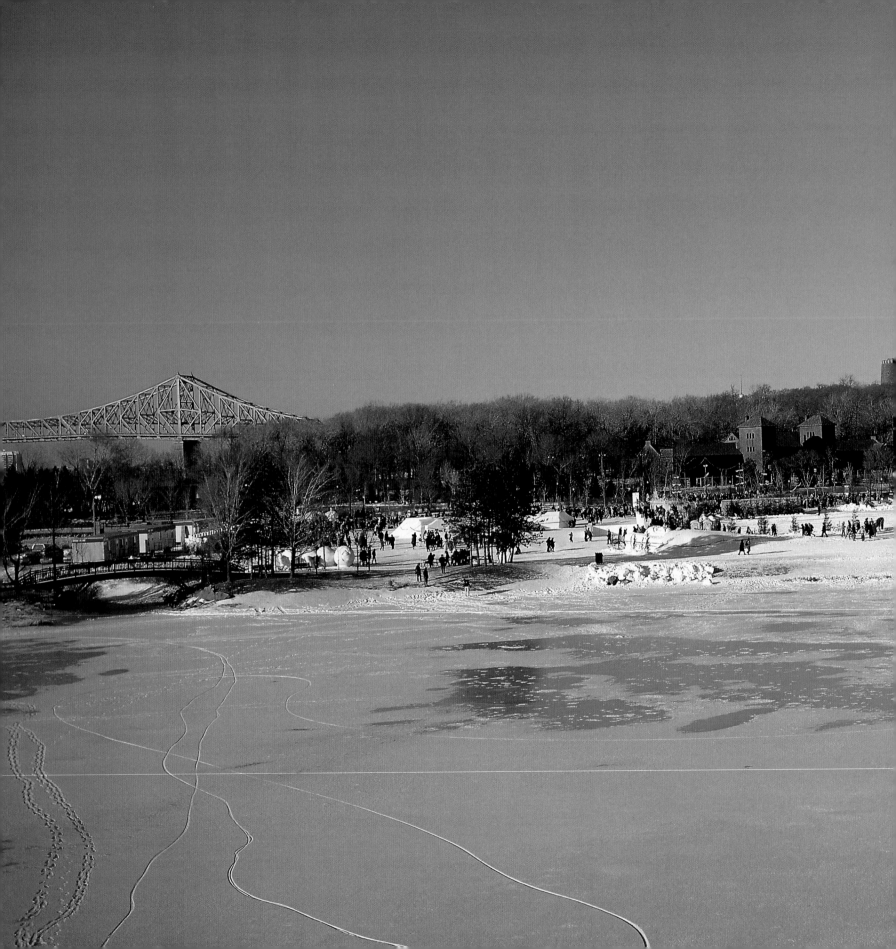

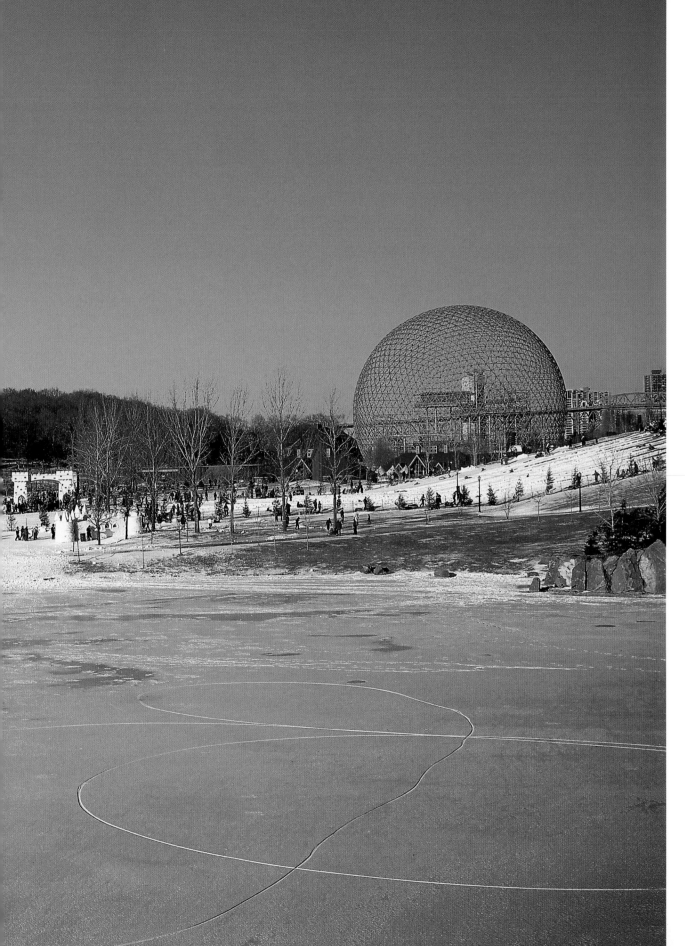

Quebec produces 10 percent of the world's fresh water supply. The Biosphere, a huge geodesic dome, was built by Buckminster Fuller as the U.S. pavilion at Expo '67. The facility is dedicated to exploring the relationships among water, people, and plant and animal life.

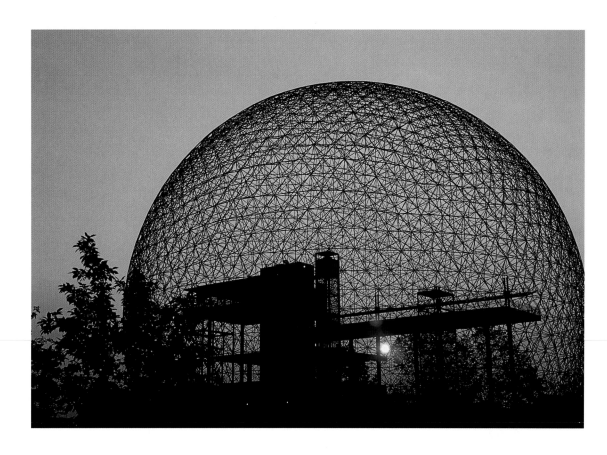

With displays, activities, and lectures, the staff of the Biosphere strives to educate the public about the ecosystems of the St. Lawrence River and the Great Lakes, as well as the importance of water to all life.

With 10 greenhouses and 26,000 species of plants, Montreal's Botanical Garden is the world's second largest, after Kew Gardens in England. It was founded in 1939 by Brother Marie-Victorin, a professor at the Université de Montréal. As well as a beautiful afternoon escape, the garden is the most popular place in the city for wedding photos.

The Montreal-Shanghai Friendship Garden, a traditional Chinese garden, is just one of 30 theme areas in the Botanical Garden. The largest Chinese garden outside Asia, it was designed in Shanghai. Artists from China travelled to Montreal to create the pavilions and pathways. It opened in 1991.

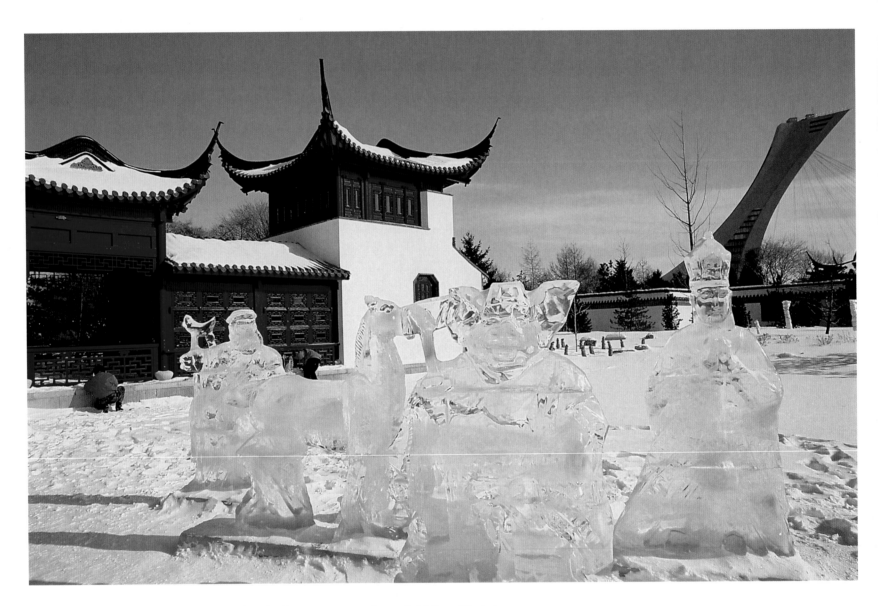

When a giant ice palace was built for a carnival in 1883, officials worried that the harsh symbol of winter would scare tourists and potential residents away. The palace drew hundreds of visitors, however, and ice sculptures have remained a favourite part of Montreal's winter months.

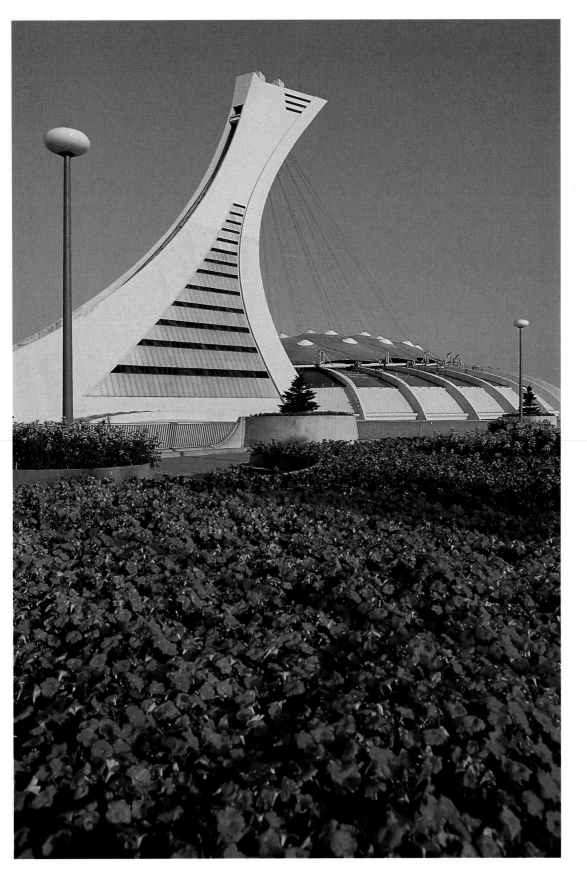

Completed more than a decade after it was begun for the 1976 Olympics, the Olympic Stadium boasts the world's tallest inclined tower.

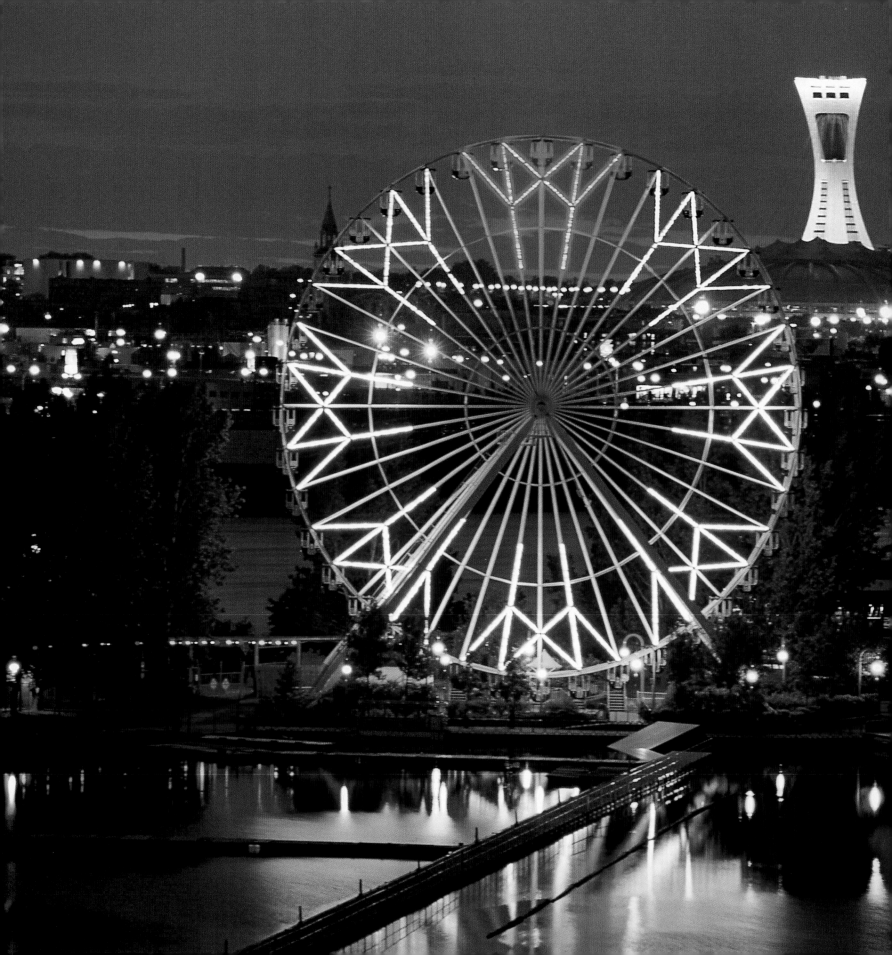

In preparation for Expo '67, the city used landfill to double the size of Île Ste-Hélène and create Île Notre-Dame nearby. La Ronde amusement park was built on the grounds. Its roller coaster, water slides, and many other heart-stopping rides make it a popular stop for the city's children.

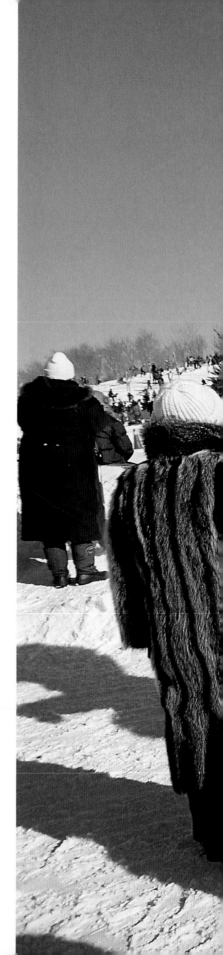

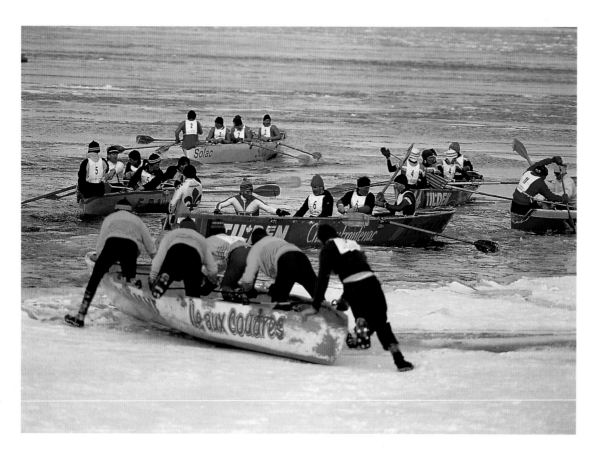

Paddlers splash their way into the icy St. Lawrence
in one fast-paced event.

Montreal's Snow Festival is a time to ignore the
chilly February temperatures and join the outdoor
fun. The cheerful Boulle de Neige — Snowball —
leads the festivities.

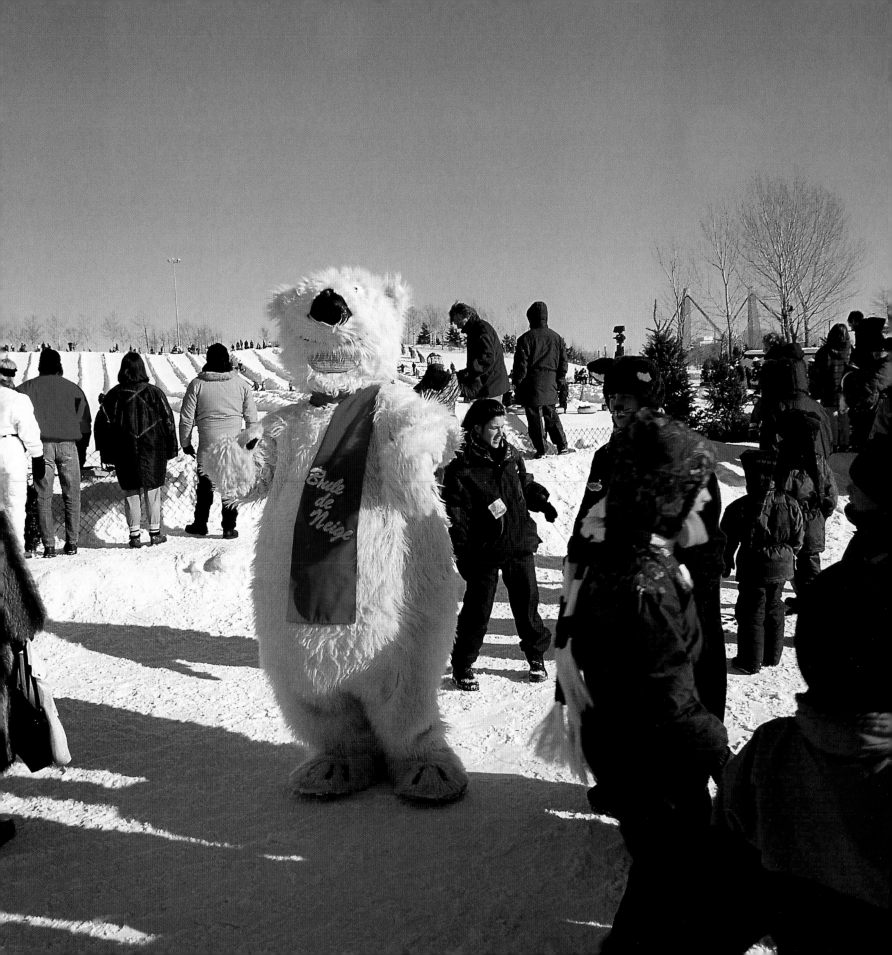

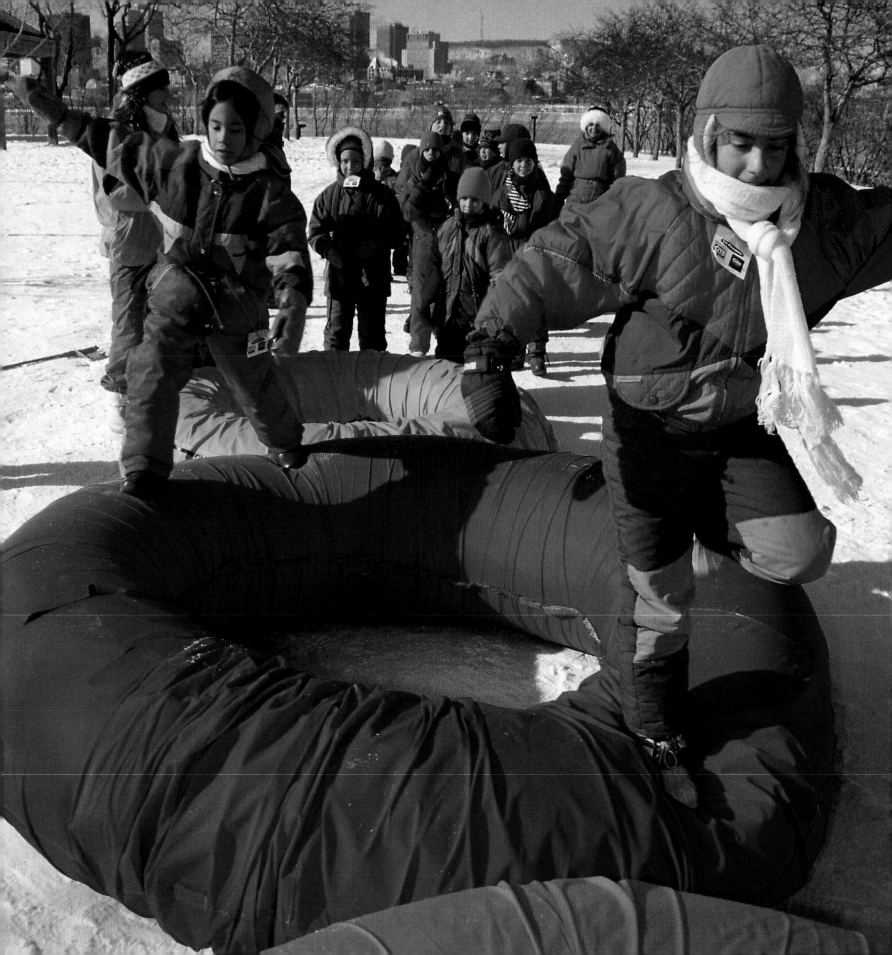

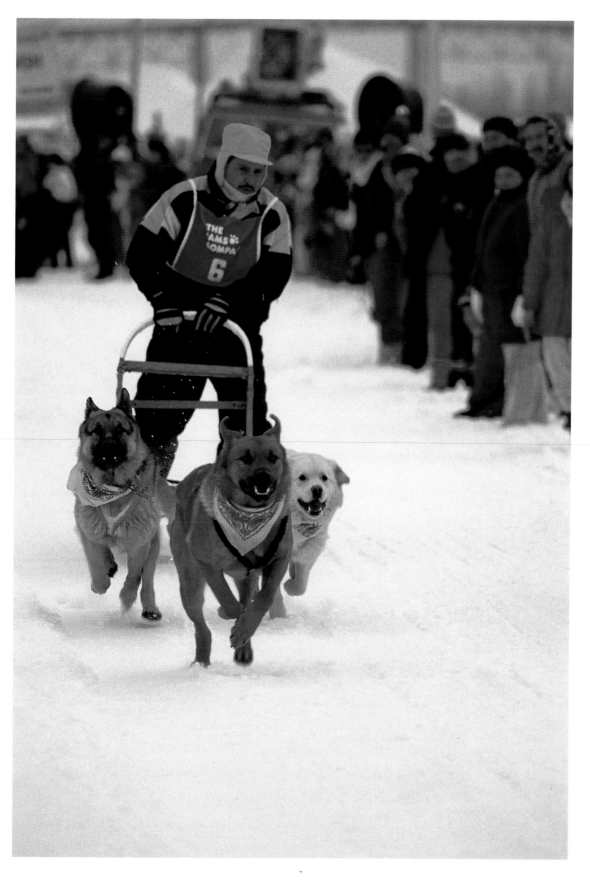

Winter activities include unusual events such as this exciting dogsled race. When they're not racing, some teams offer rides to children and families.

FACING PAGE—Skating, sledding, cross-country skiing, and other events, as well as a myriad of children's games, fill Parc des Îles de Montréal, on Île Ste-Hélène and Île Notre-Dame, during the Snow Festival.

The posh Casino, designed in a style reminiscent of Monte Carlo, offers more than 100 gaming tables and 2000 slot machines. Housed in the Expo '67 French pavilion, the casino draws thousands of visitors each day.

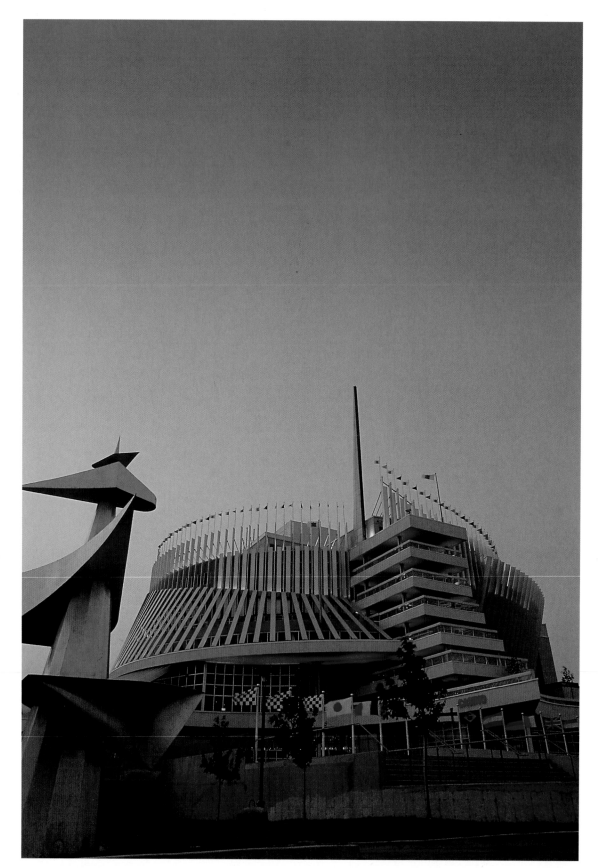

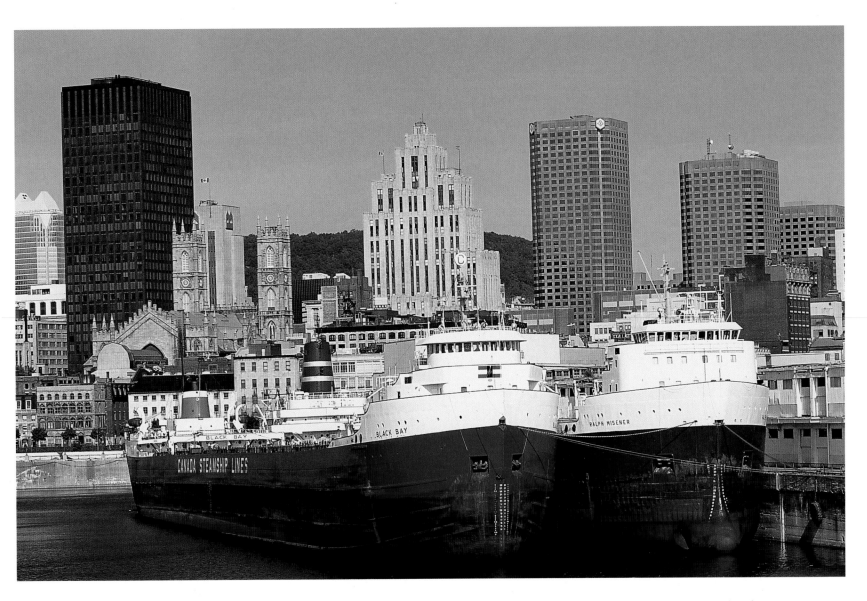

Spanning 25 kilometres of shoreline, Montreal's port is the largest inland port in North America. Since the 19th century, the river has been regularly dredged to make it safe for shipping vessels to navigate its route. It was Canada's busiest port in the mid–1800s.

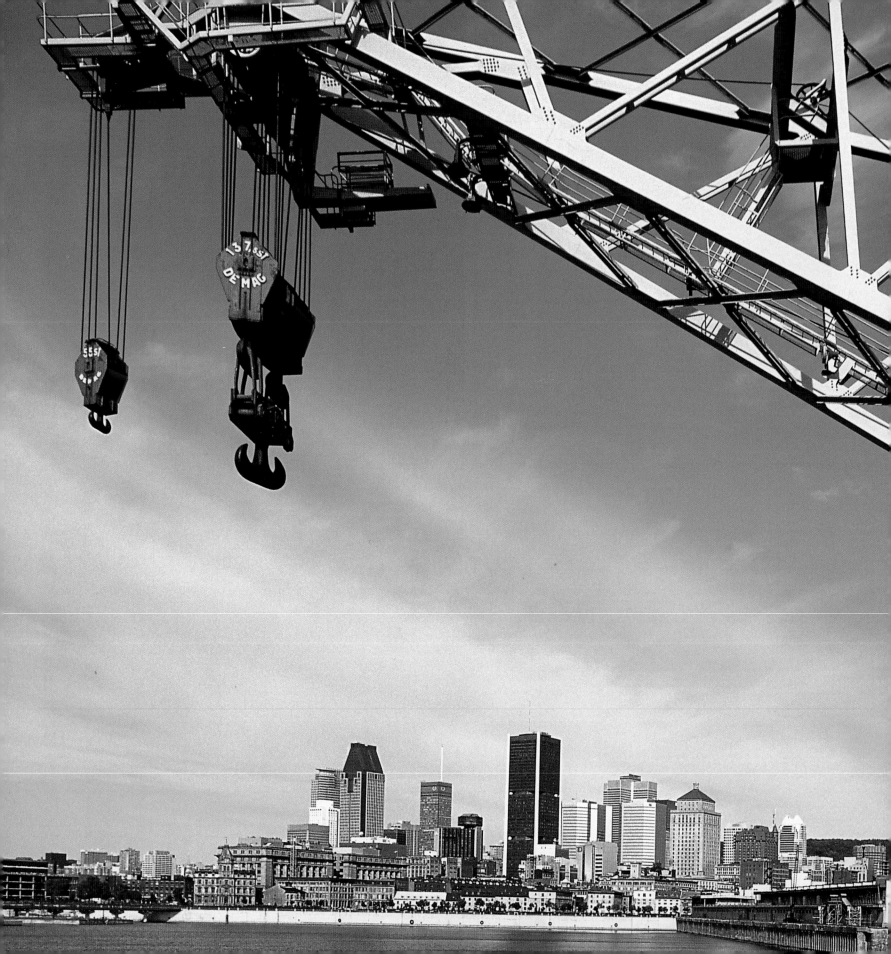

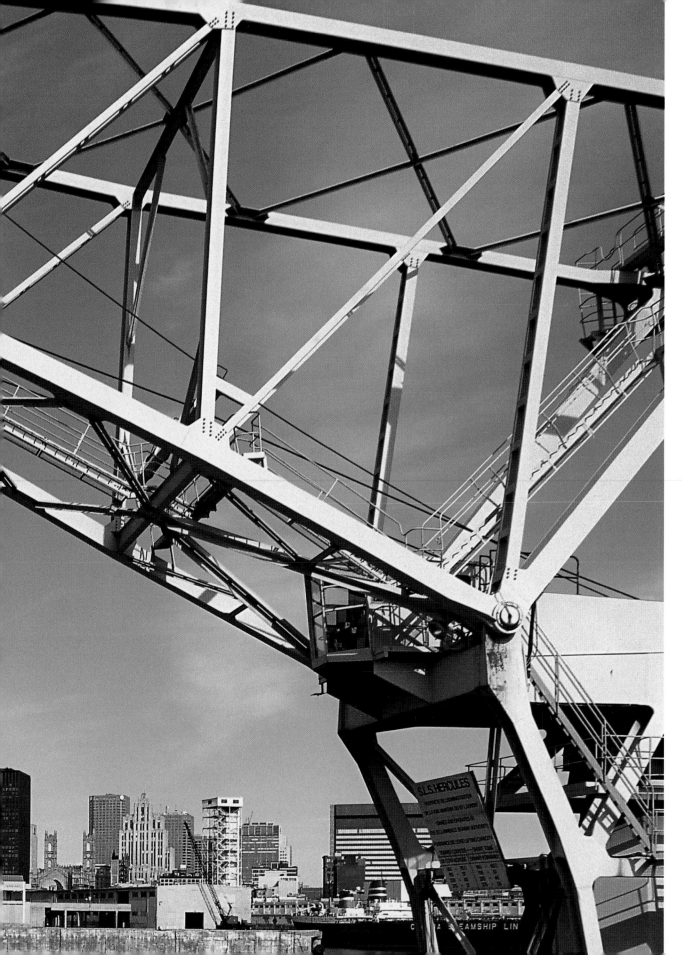

The trade brought
by the St. Lawrence
River has been
crucial to Montreal
since fur traders
began meeting
here in the 17th
century, at the base
of the rapids.

49

Mirrored glass and steel, modern architecture, and skyscrapers such as the Maison des coopérants help give downtown Montreal its cosmopolitan feel.

FACING PAGE— Just over one million people live in the city of Montreal. About two million more live in the surrounding areas. The island itself measures 32 kilometres at its longest point and is about 16 kilometres wide.

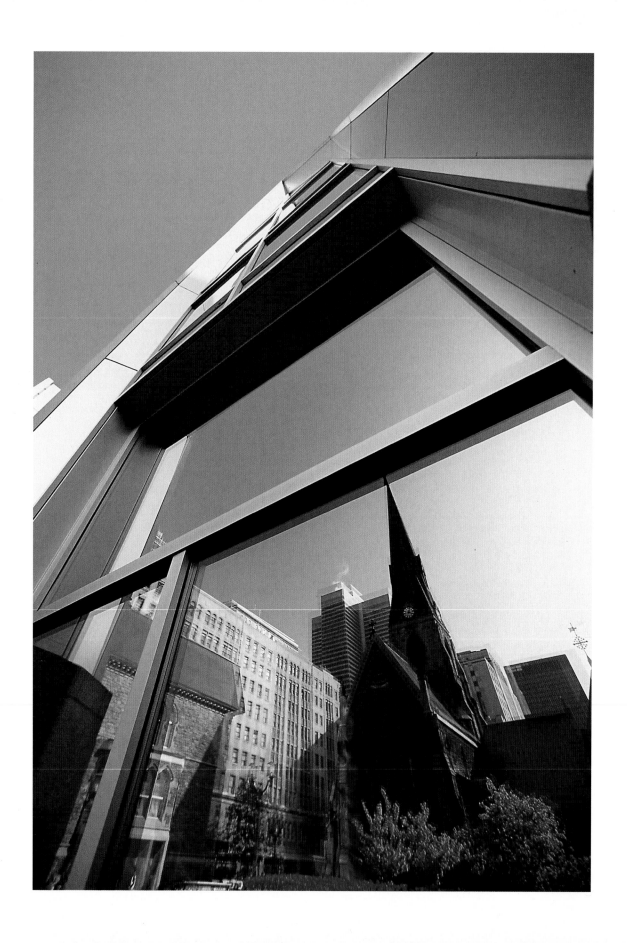

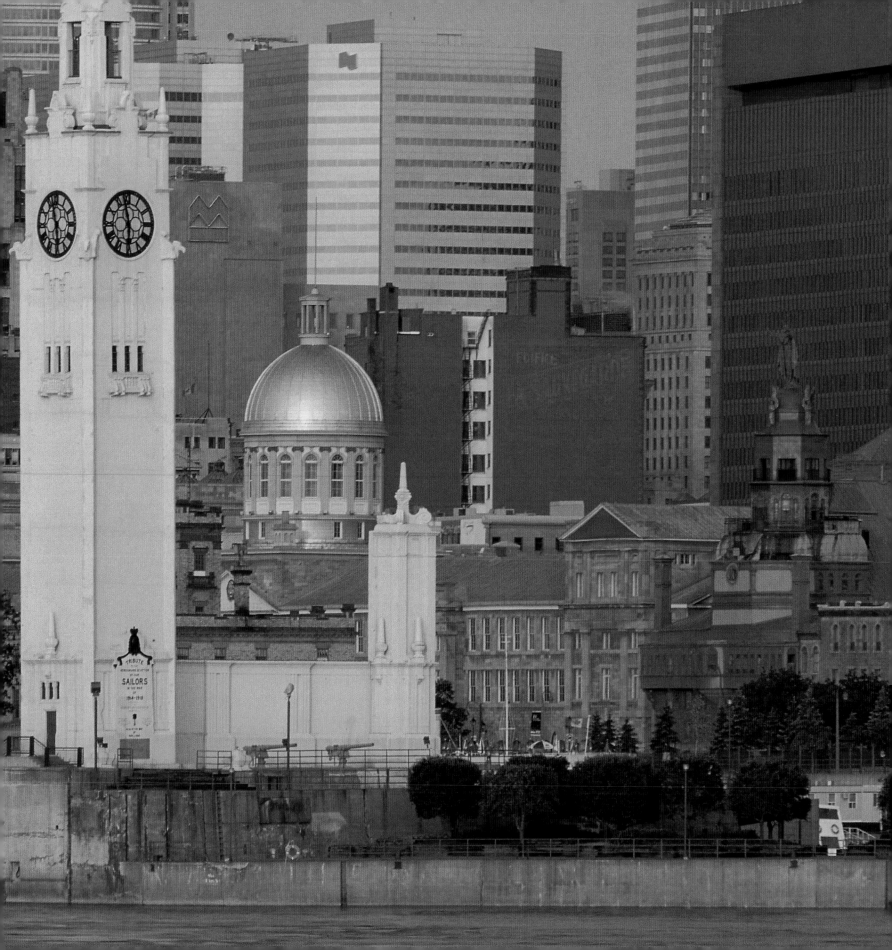

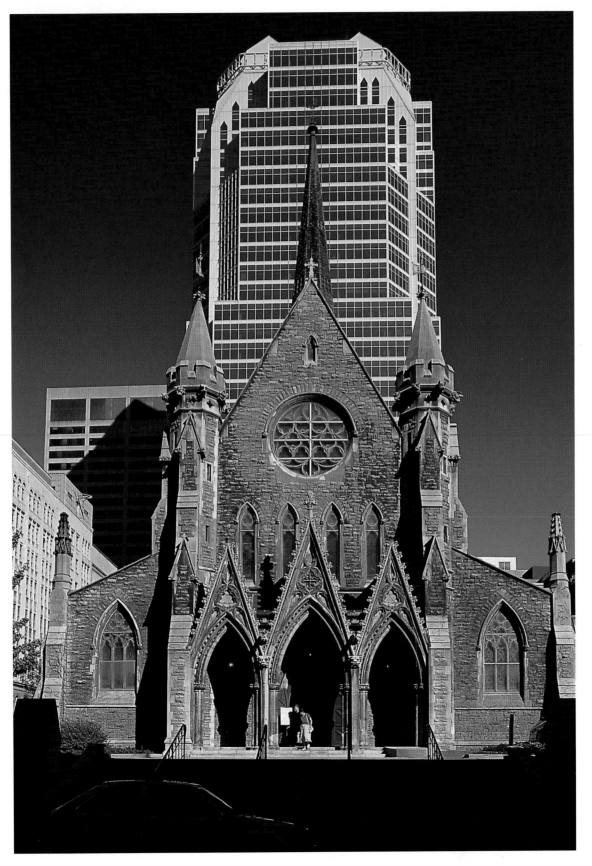

Christ Church Cathedral was built in 1859. When the church lands were leased to developers in 1988, the land beneath the church was excavated to make room for retail outlets. Maison des coopérants, a modern office tower, was built above.

FACING PAGE— When it began more than 15 years ago, the Just For Laughs comedy festival was a small event featuring only French Canadian performers. It's now held for 12 days each July, and past years have featured such performers as Roseanne, Jay Leno, and Mary Tyler Moore.

53

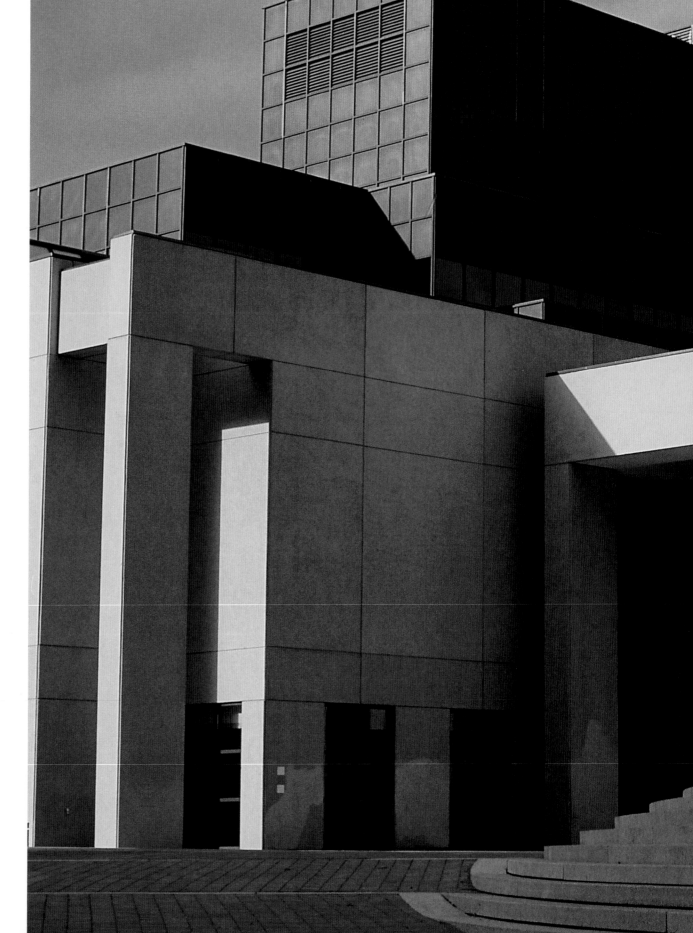

Visitors to the Montreal Museum of Contemporary Art will discover about 5000 works, over half of them by Quebec artists such as Jean-Paul Riopelle and Adolph Gottlieb. This is the only museum in Canada that is dedicated to modern art.

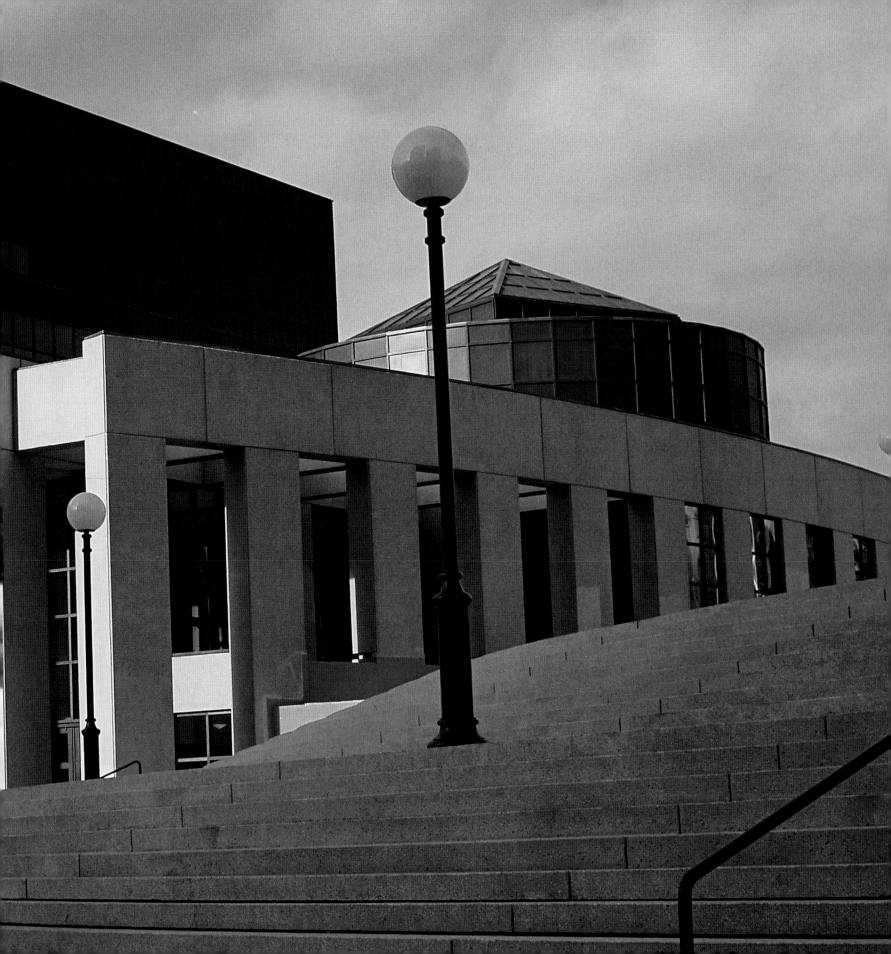

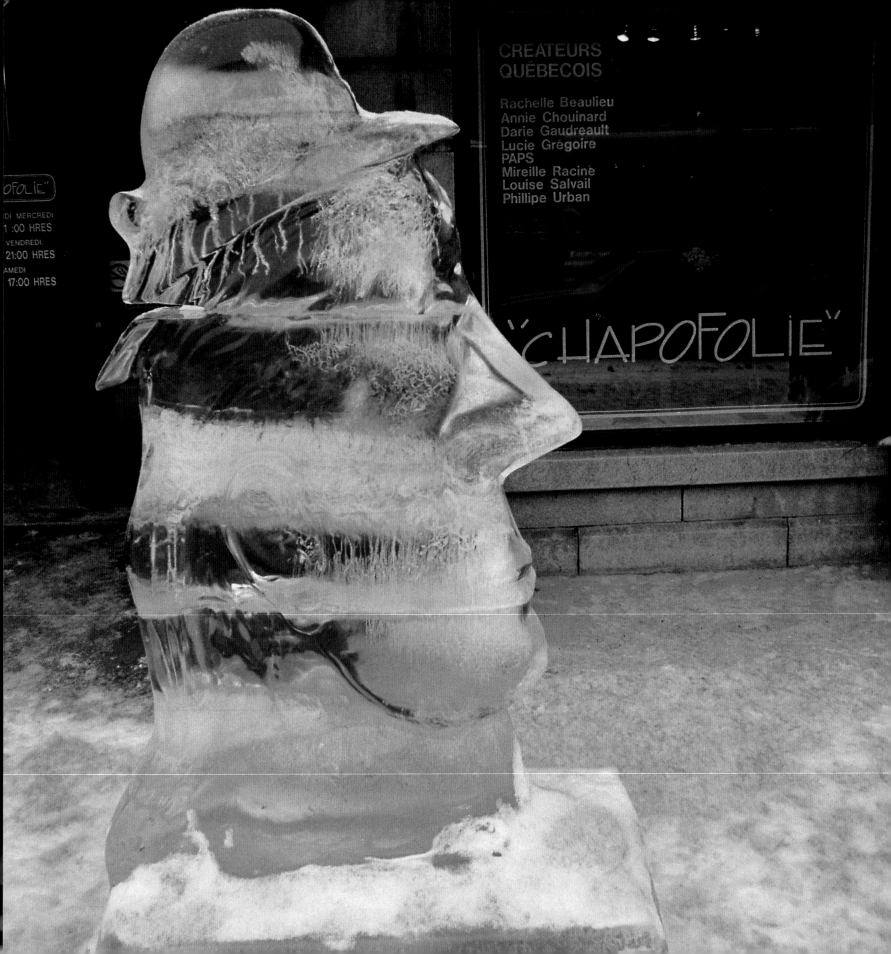

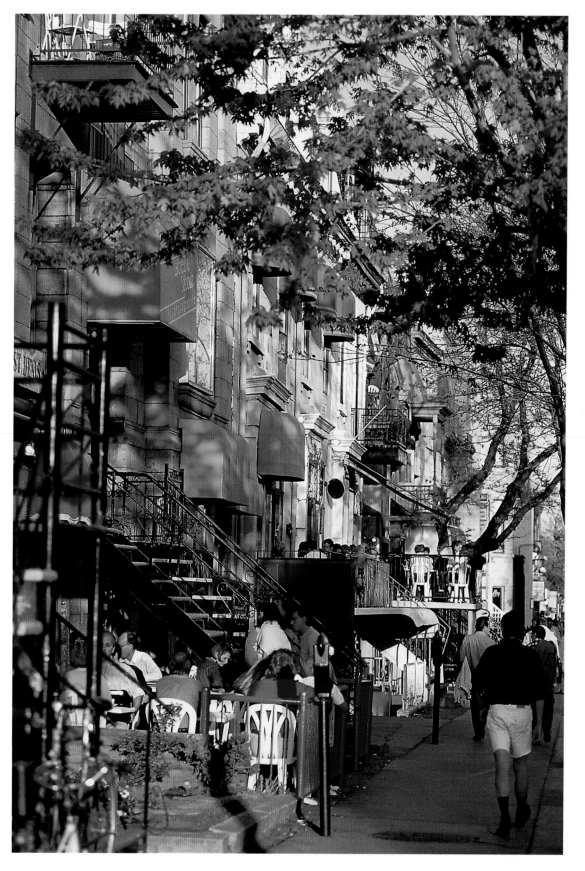

Bookstores, cafés, galleries, antique stores, and artists' studios help create the avant-garde atmosphere along St. Denis and in the Latin Quarter.

FACING PAGE— St. Denis was a wealthy residential area in the 1800s. Now, its cafés and shops draw student crowds from the nearby Université du Québec à Montréal.

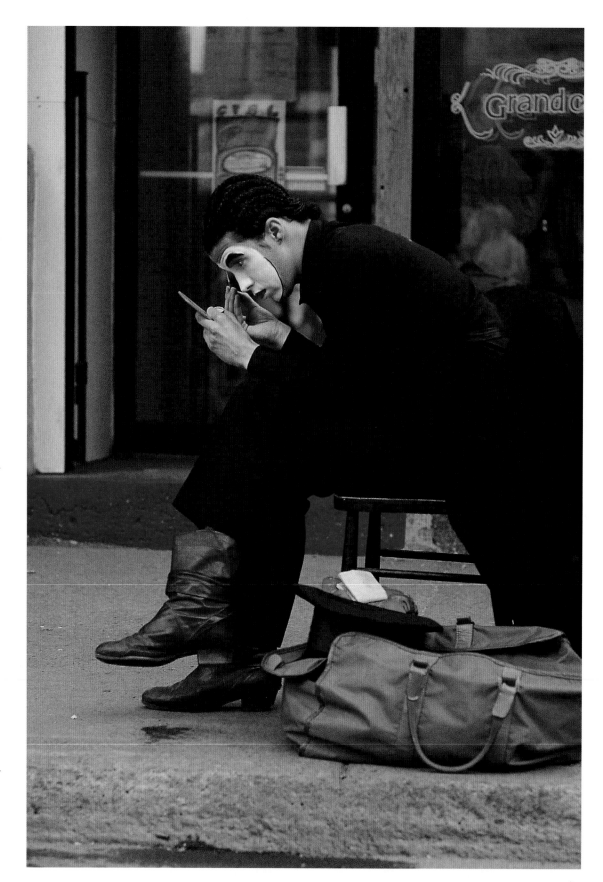

A street magician applies his makeup. With more than 200 festivals in Quebec each year, he has plenty of opportunity to perform.

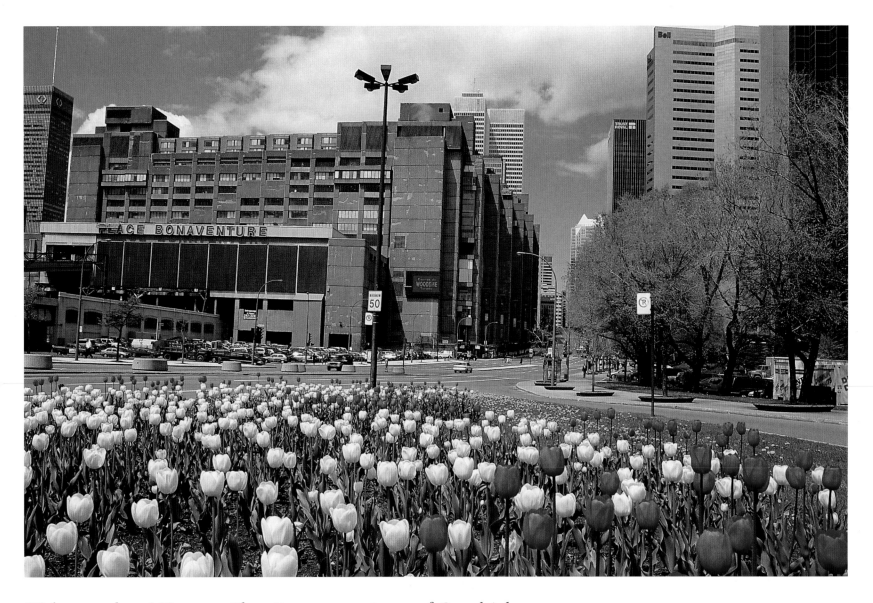

With more than 100 stores, Place Bonaventure is one of Canada's largest
commercial buildings and the perfect place for a shopping extravaganza.
The complex also houses offices and The Bonaventure Hilton International.

Overleaf—
The architecture of Mary Queen of the World Cathedral echoes that of
St. Peter's Basilica in Rome. Planned by Bishop Ignace Bourget after the
previous Catholic cathedral burned down, the first stone for this structure
was laid in 1870. It took 24 years to complete.

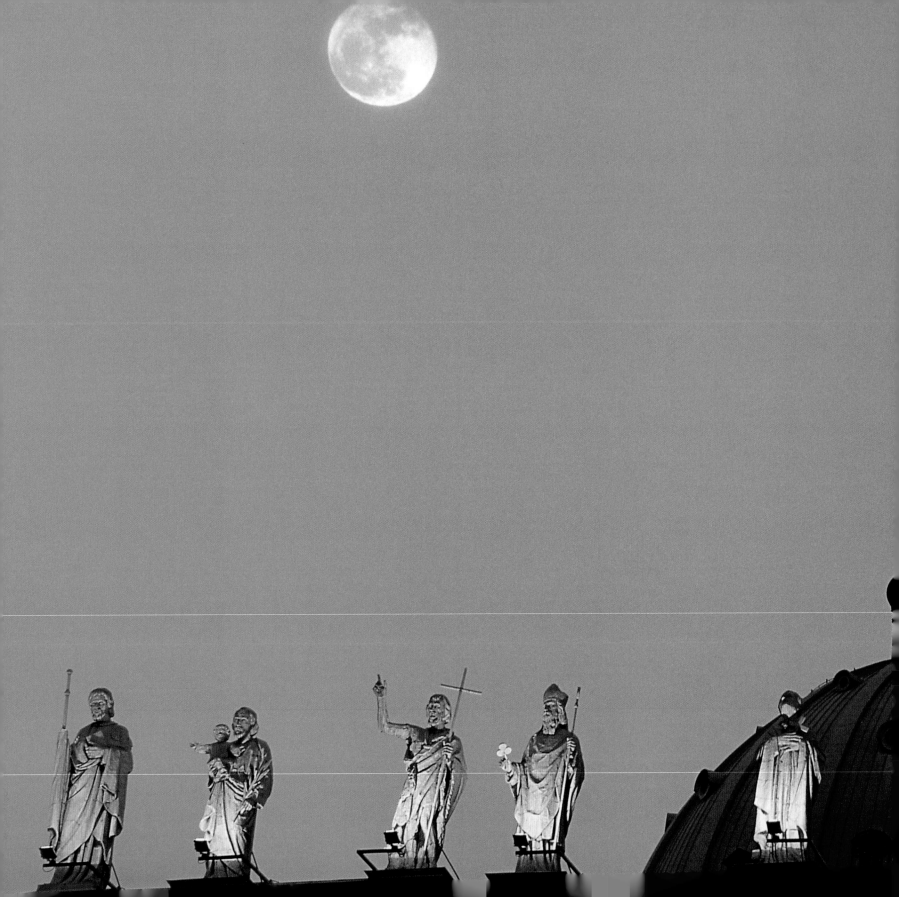

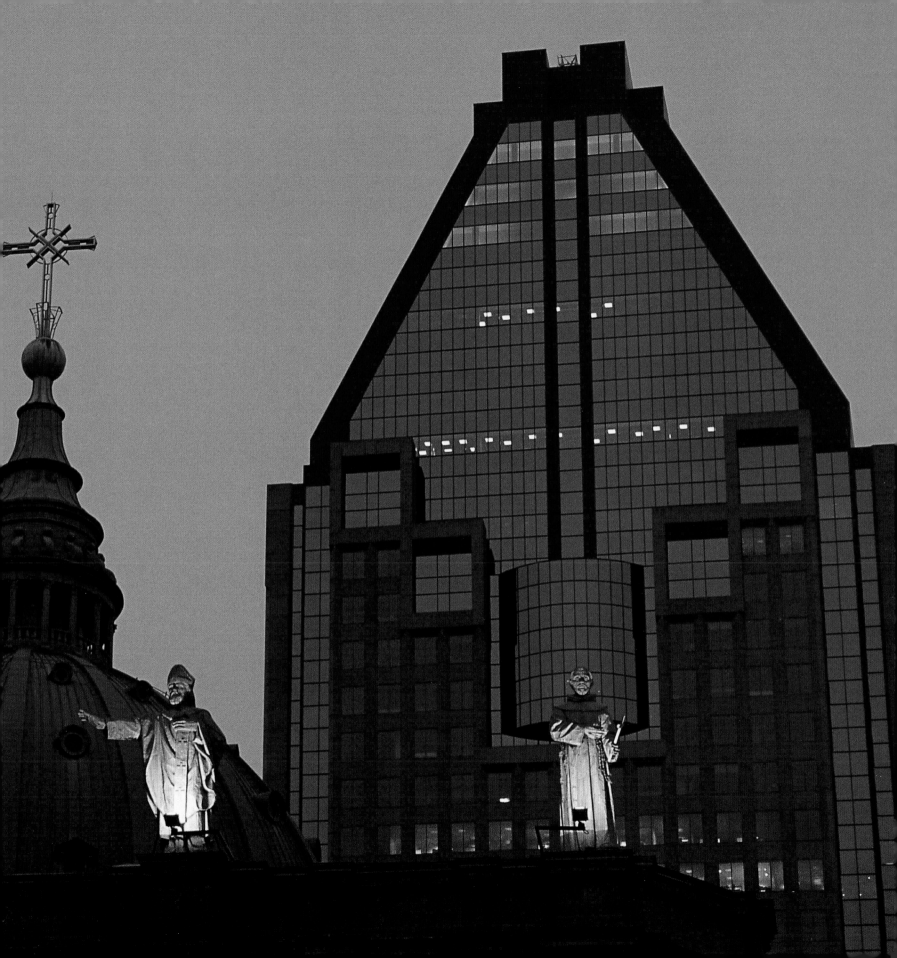

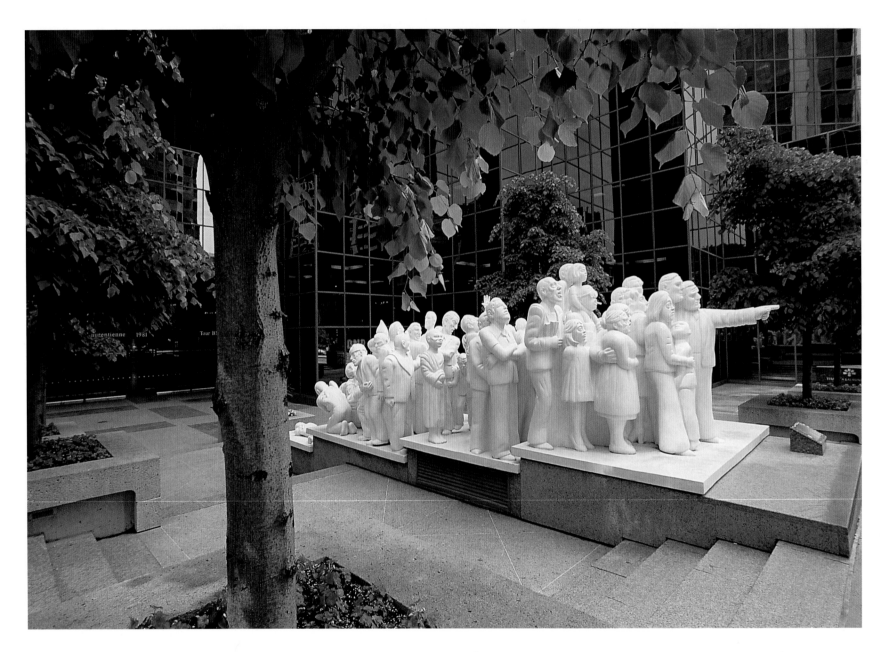

The Illuminated Crowd was created by Toronto artist Raymond Mason in 1979. Its white figures reflect off the glass of the BNP Tower, home of the Banque Nationale de Paris.

The McGill University grounds were once the estate of Scottish immigrant James McGill, who made his fortune in fur trading in the late 1700s. A graduate of the University of Glasgow, McGill believed strongly in education, and willed his land for the express purpose of building a university.

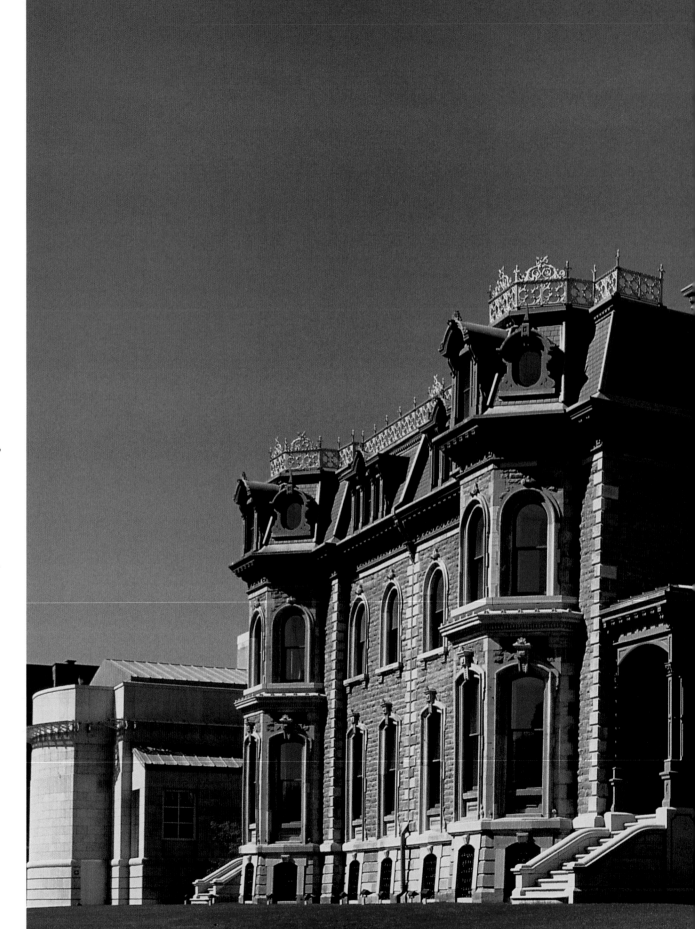

The Canadian Centre for Architecture is filled with blueprints, models, drawings, and photographs. Its founding in 1989 by Phyllis Lambert, heir to the Seagram fortune, saved the historic Shaughnessy House from demolition. Built in 1874, the mansion is named after past resident Sir Thomas Shaughnessy, a president of Canadian Pacific. It is reminiscent of many of the mansions that once lined this street.

64

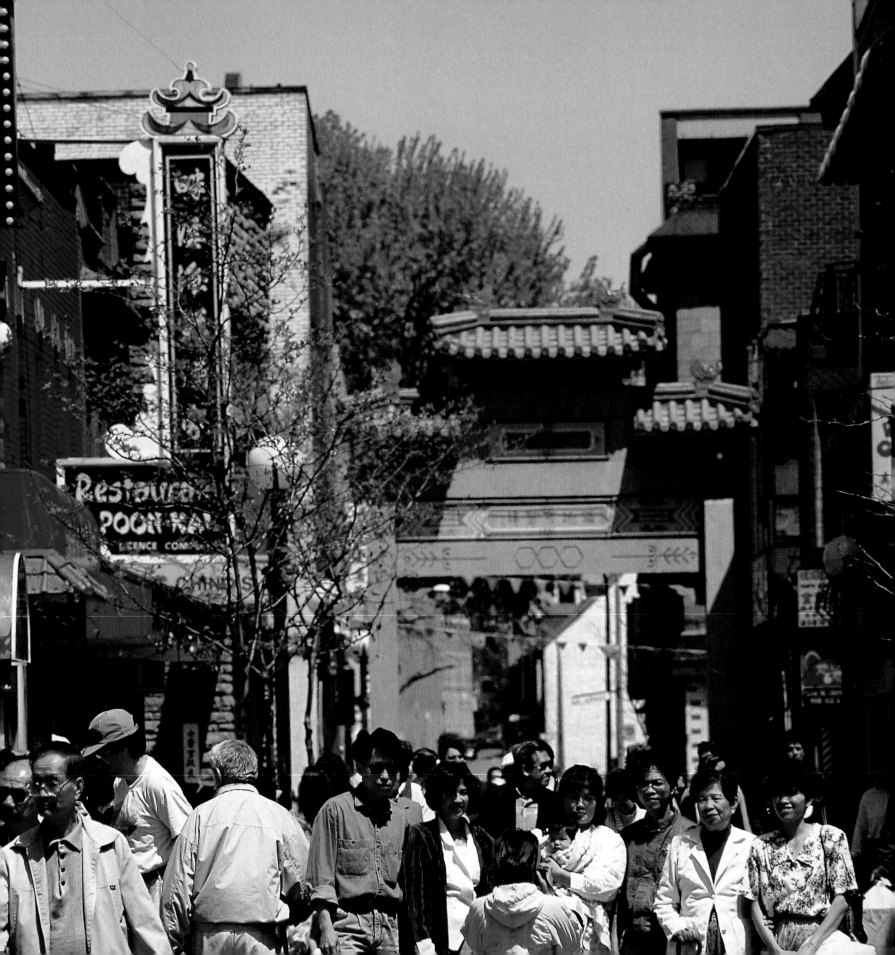

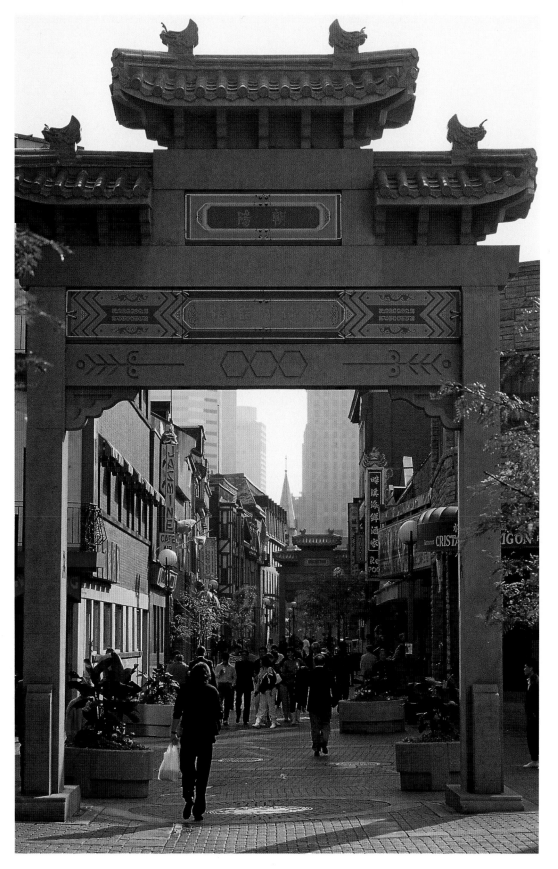

The first Chinese immigrants arrived in Montreal in the late 1880s after the completion of the transcontinental railway. Though the Chinese population has since dwindled, the streets of Chinatown still boast colourful specialty shops and restaurants.

FACING PAGE— One of the favourite places to visit in Chinatown is Rue de La Gauchetière, where pedestrians wander through stylized gates past an array of popular restaurants.

If you stop at the Queen Elizabeth Hotel, you may find flowers outside Room 1742. John Lennon and Yoko Ono held a love-in here in 1969. On the more formal occasion of Expo '67, the hotel was home to 50 international heads of state.

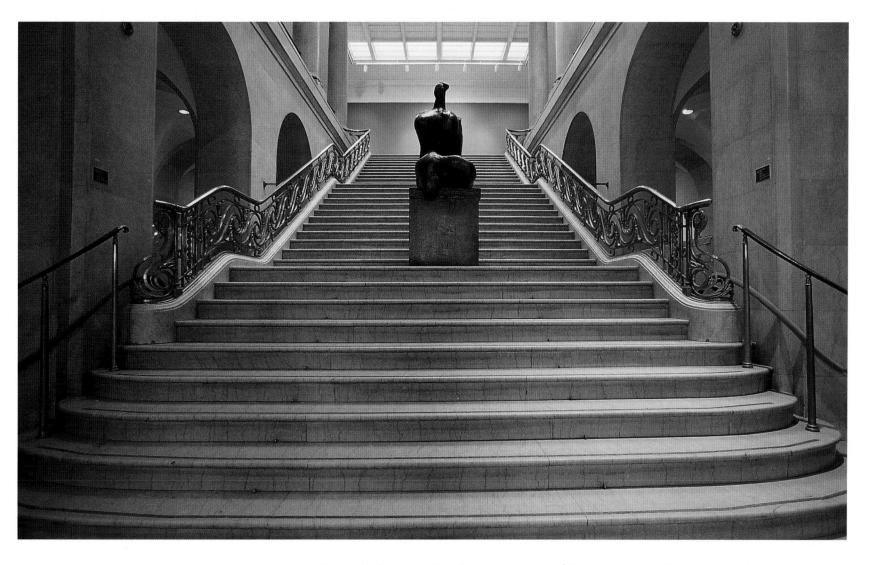

Founded in 1860, the Museum of Fine Arts is Canada's oldest museum. It includes the Benaiah Gibb Pavilion, featuring Canadian art, and the newer Jean-Noël Desmarais Pavilion, with ancient and contemporary art from around the world. Architect Moshe Safdie, creator of Habitat, designed the Desmarais Pavilion, which opened in 1991.

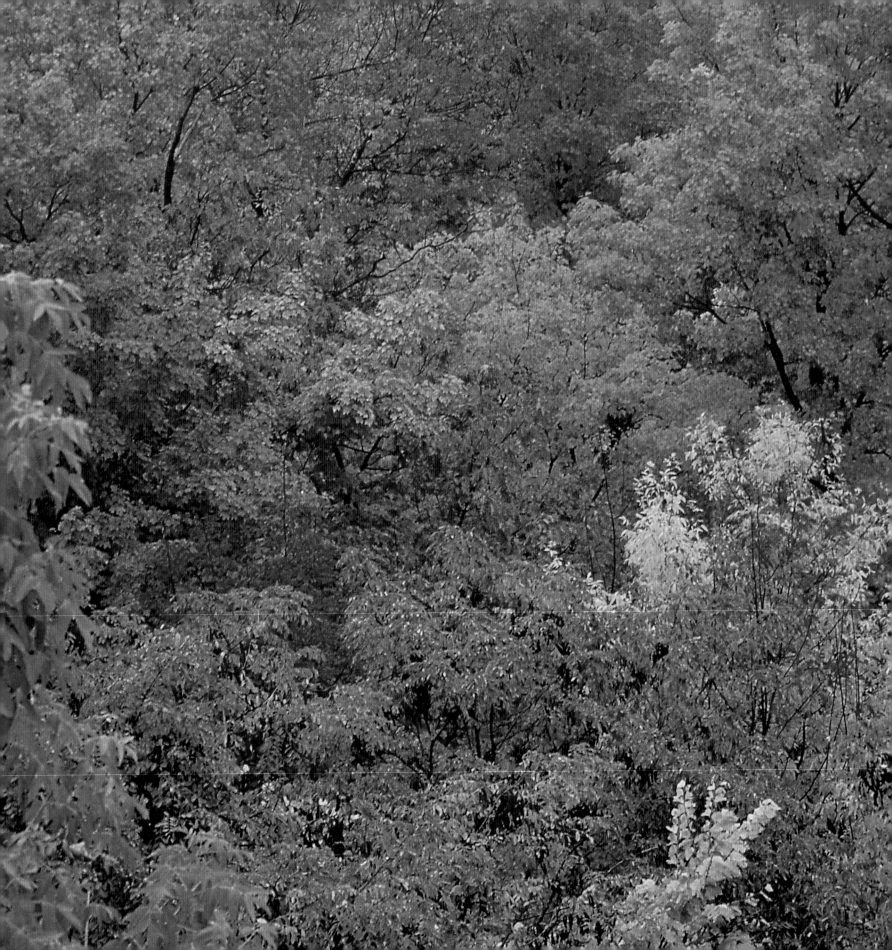

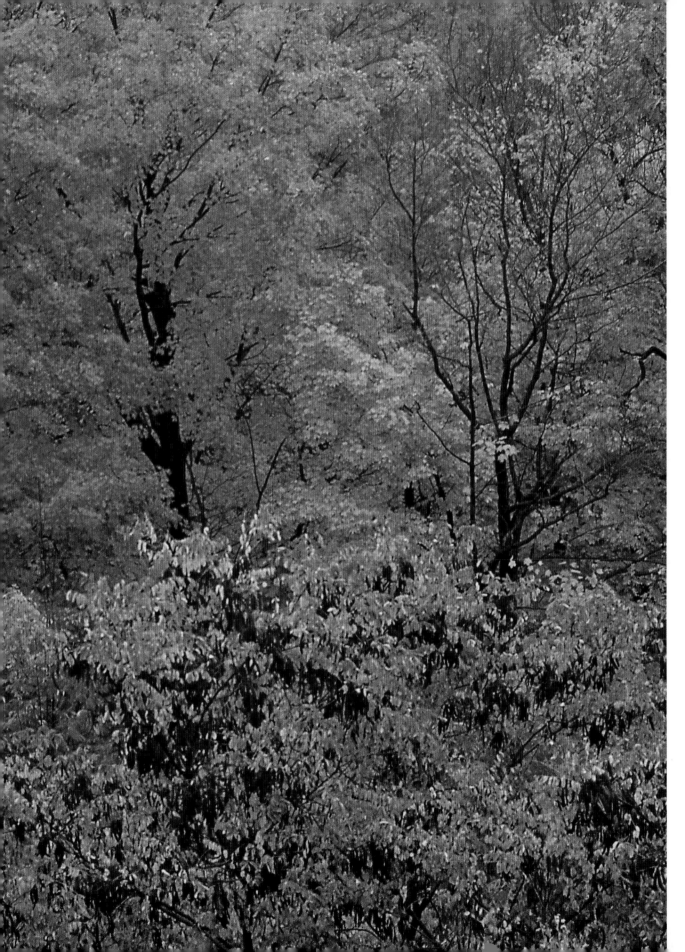

In the autumn the trees of Montreal's parks blaze with the same bright colours for which the Laurentian Mountains and the Quebec countryside are known.

71

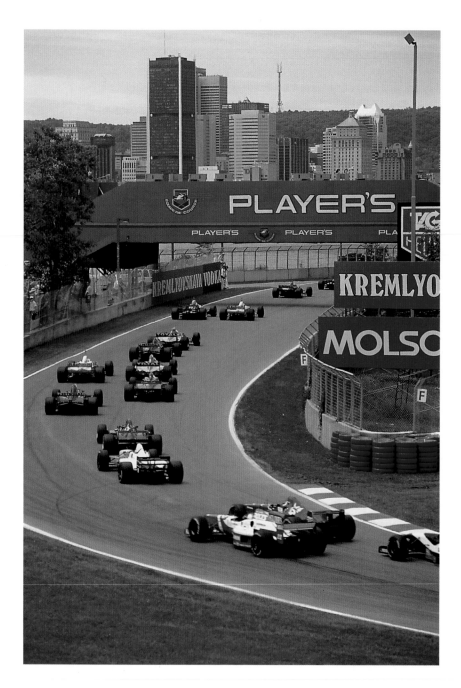

Formula One drivers from around the world race in Montreal's Grand Prix each June.

French Canadian Formula One driver Gilles Villeneuve died in a crash in 1982, just five weeks before he was to compete in the Canadian Grand Prix in Montreal. The Gilles Villeneuve track is named in his honour. Local crowds now cheer for his son, Jacques Villeneuve.

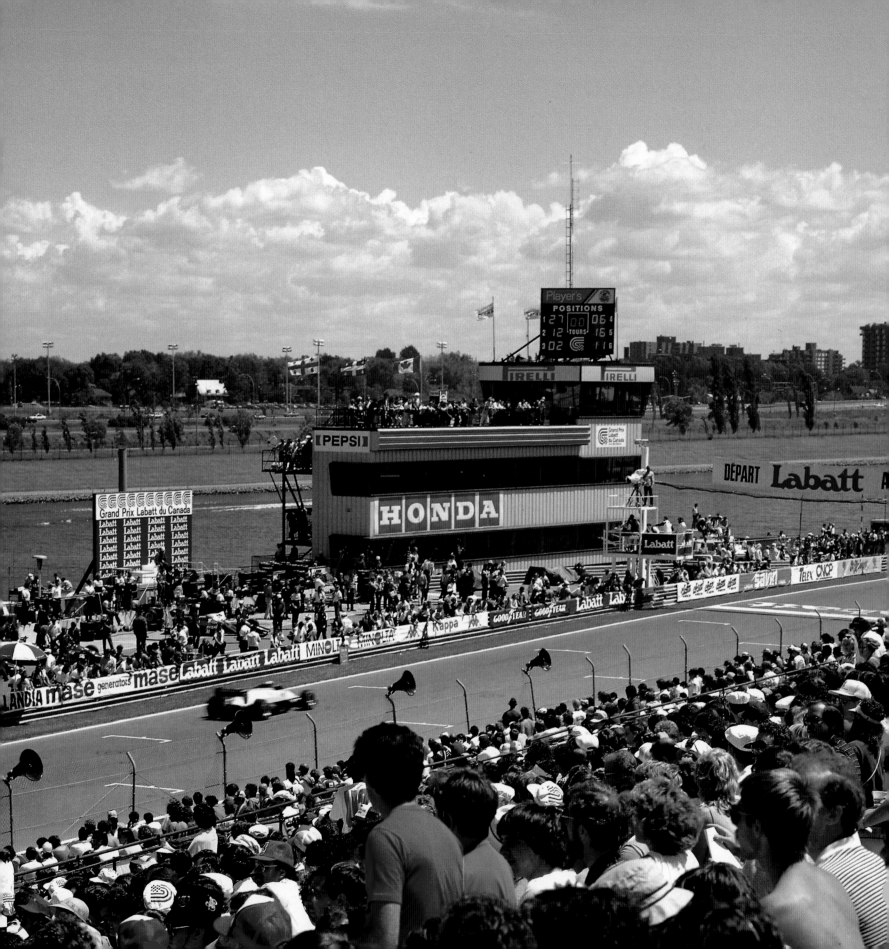

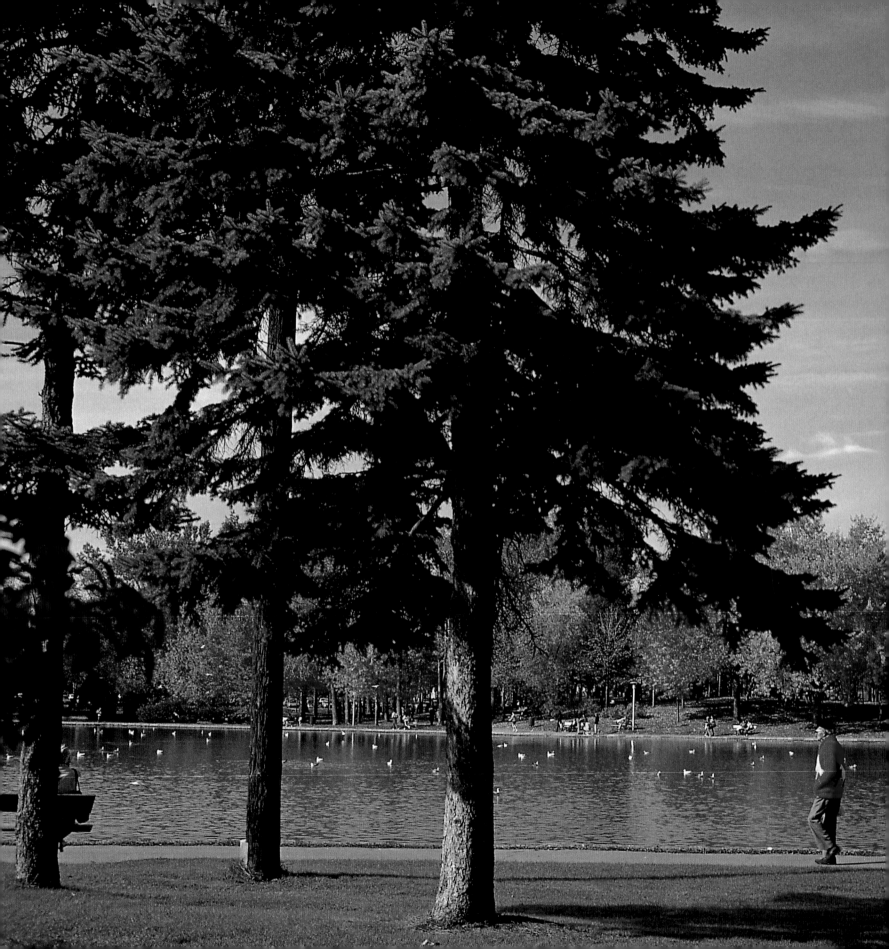

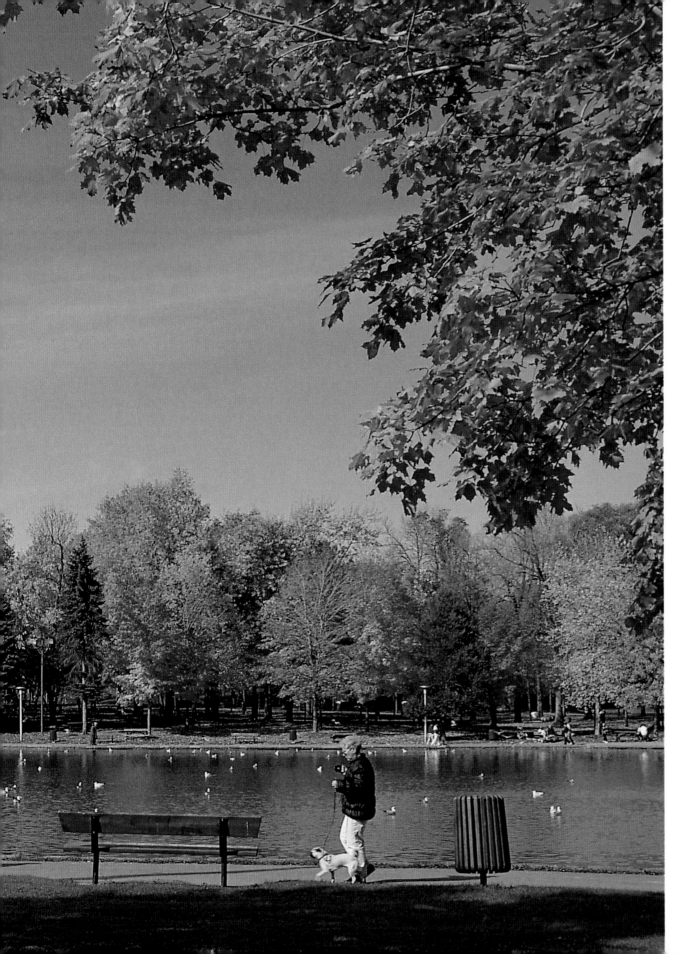

There are no beavers in Mount Royal Park's Lac des Castors—Beaver Lake. Its name commemorates the fur trade. The small lake is a favourite picnic spot in summer and a picturesque skating rink in winter.

In the spring of 1642, the St. Lawrence River threatened to flood the mission village of Ville-Marie. When the waters receded, the residents erected a wooden cross on Mount Royal. This 30-metre steel cross replaced the oak version in 1924.

FACING PAGE—
A horse-drawn carriage—calèche—provides visitors with a tour of Mount Royal Park. The gently sloped roads here were specifically designed for the carriages, which have been offering tours since the park's creation over 100 years ago.

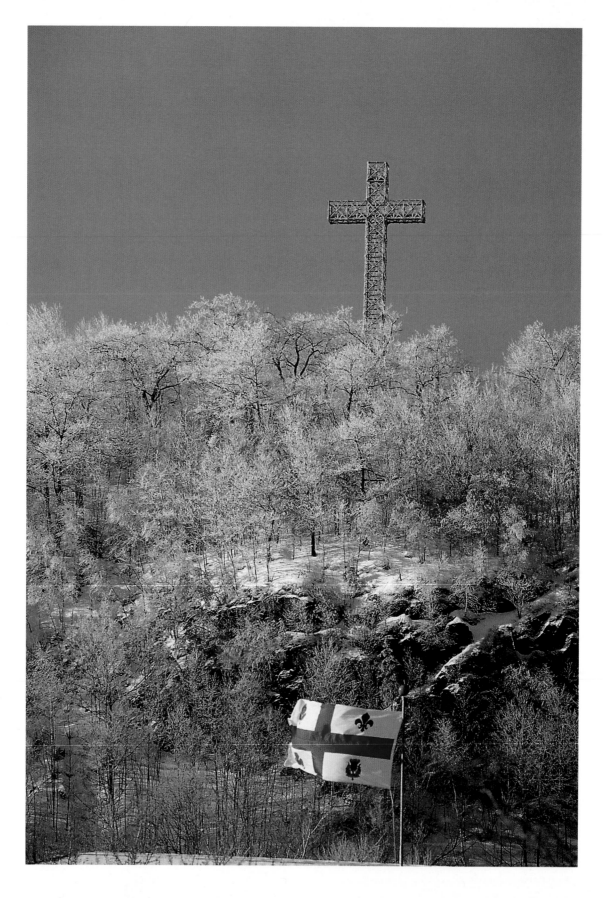

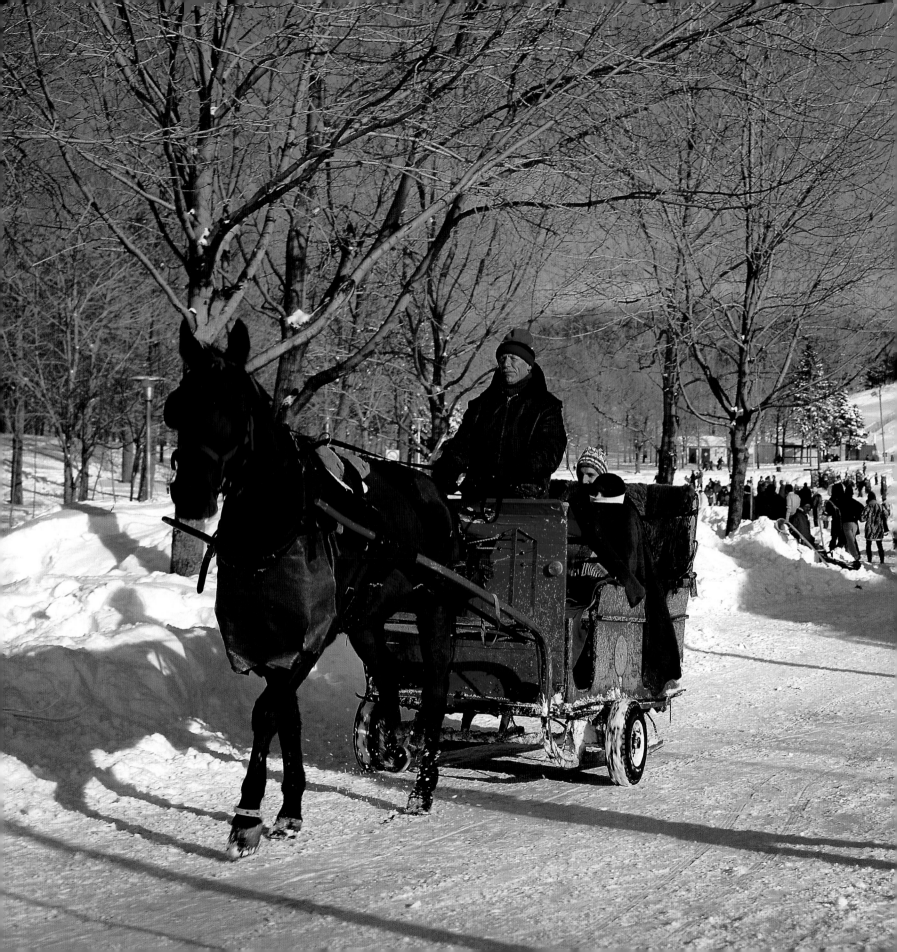

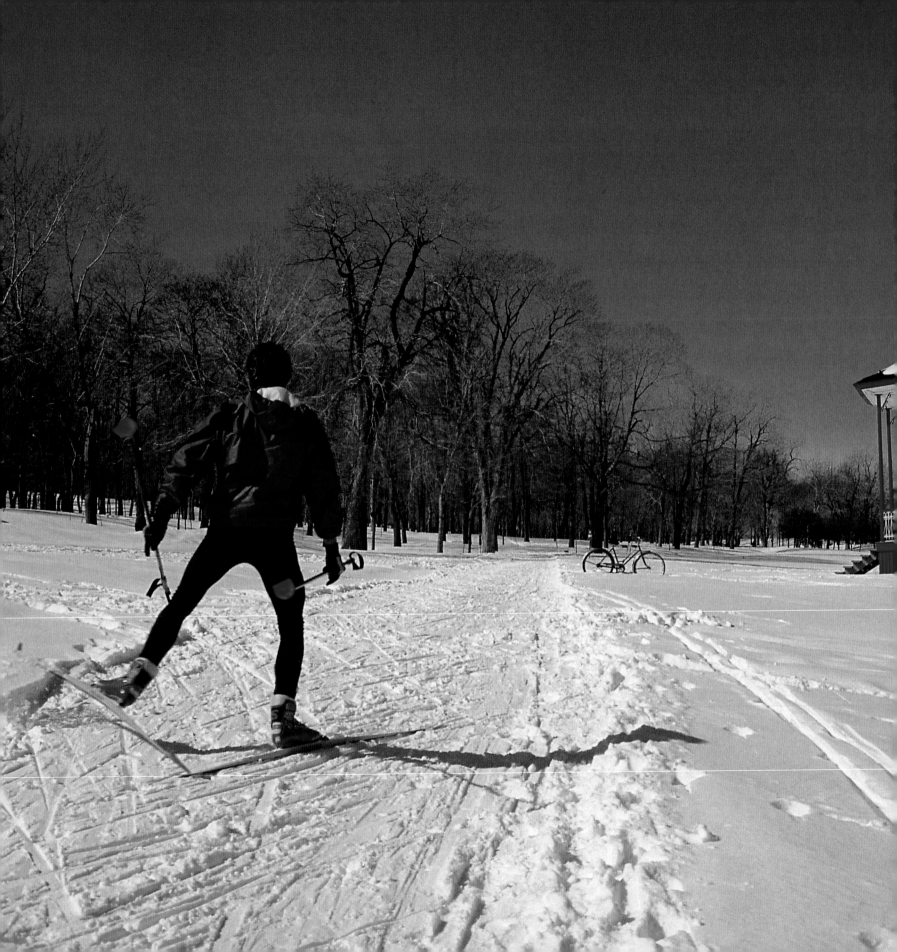

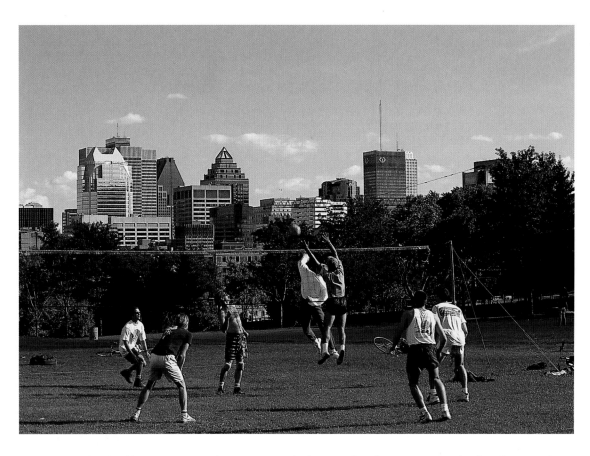

From volleyball, jogging, skating, and skiing facilities to trails for leisurely walks and quiet spots for picnics, the city's parks provide every outdoor opportunity possible within the confines of a major centre.

Cross-country skiing trails in Mount Royal Park
and the Botanical Garden give winter enthusiasts
a chance for exercise.

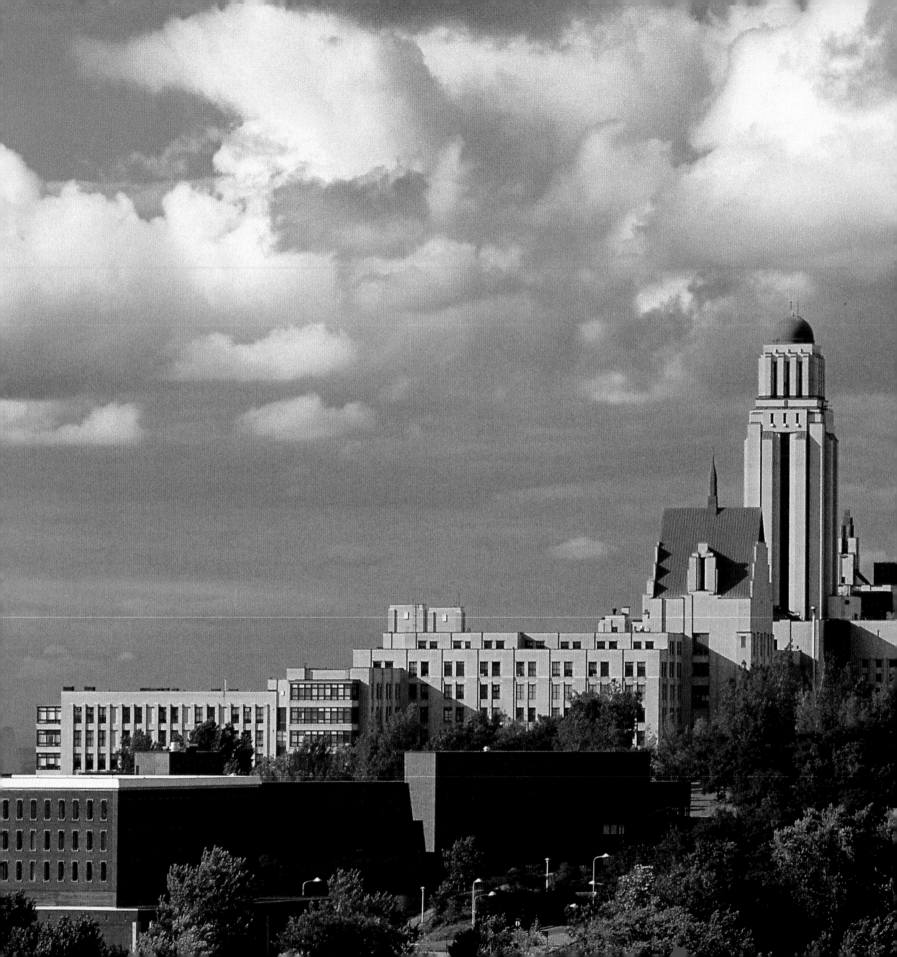

More than 40,000
students attend
classes in almost
200 degree pro-
grams at the Univ-
ersité de Montréal.

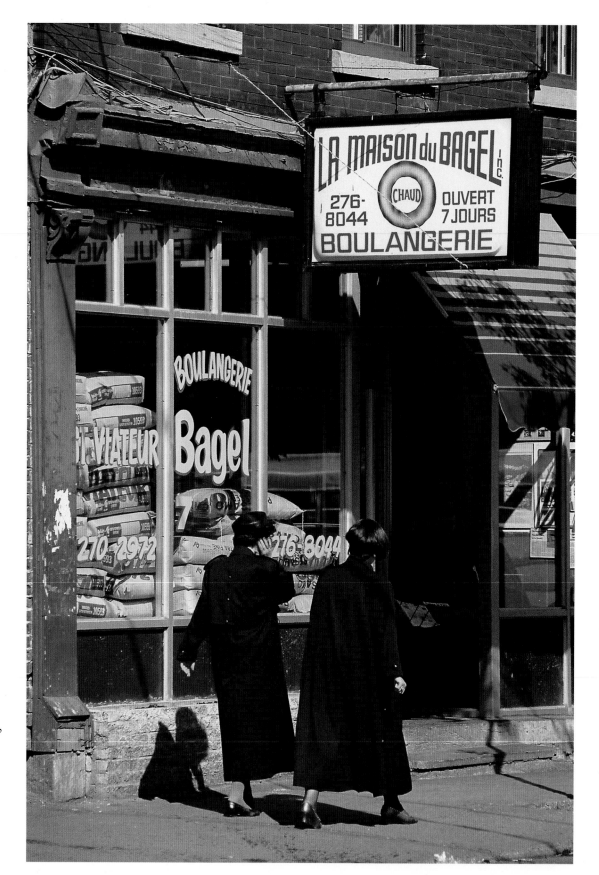

Montreal bagels are famous throughout Canada. Many bakers have tried to imitate the unique preparation methods, but none has perfected the honey-sweetened flavour.

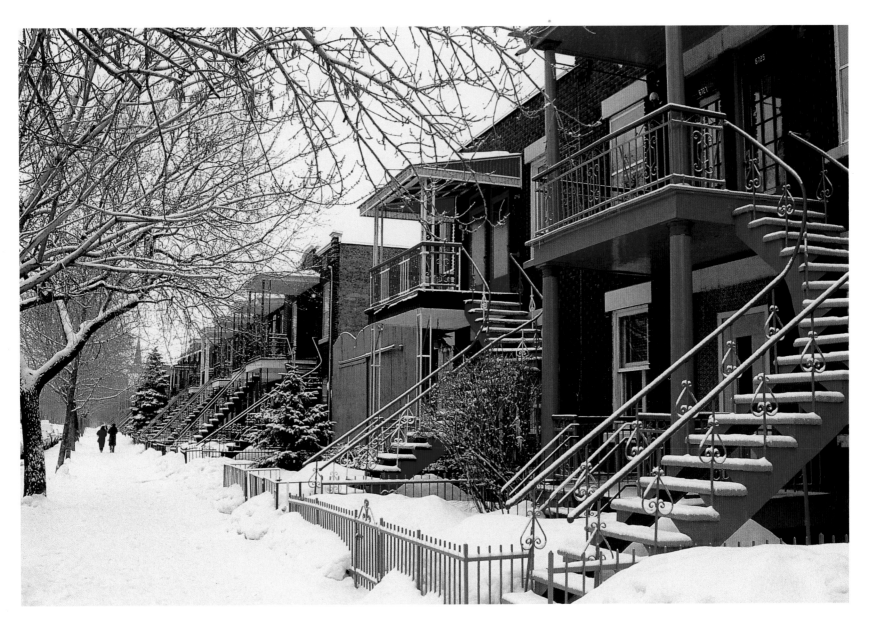

Temperatures plunge below freezing between December and March, but though the cold and snow may make for extra shoveling, they're perfect for sleighing in Mount Royal Park or skiing trips to the Laurentian Mountains.

Westmount is one of Canada's wealthiest neighbourhoods. Most of the homes here were built between 1910 and 1930. The area sits atop one of Mount Royal's three summits—the others host scenic Mount Royal Park and the Université du Quebec à Montréal.

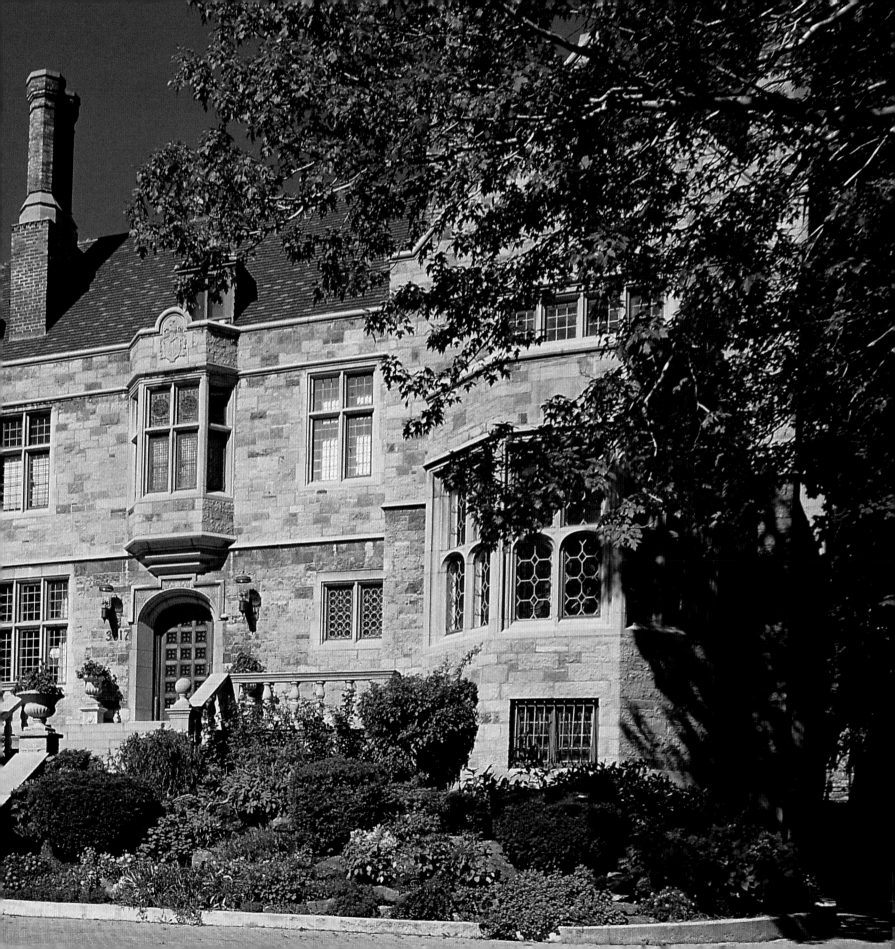

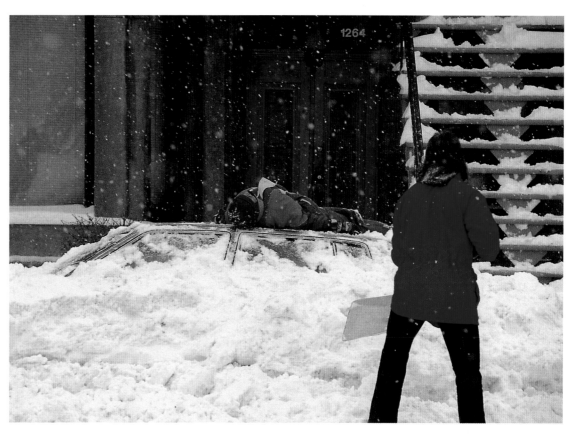

This person's young assistant has given up the struggle against Montreal's winter snowfalls.

Many of the character houses on Drolet Street and other streets in the Plateau area of Montreal were built at the turn of the century, when French Canadians from the countryside moved to the city to work in the growing number of factories and quarries.

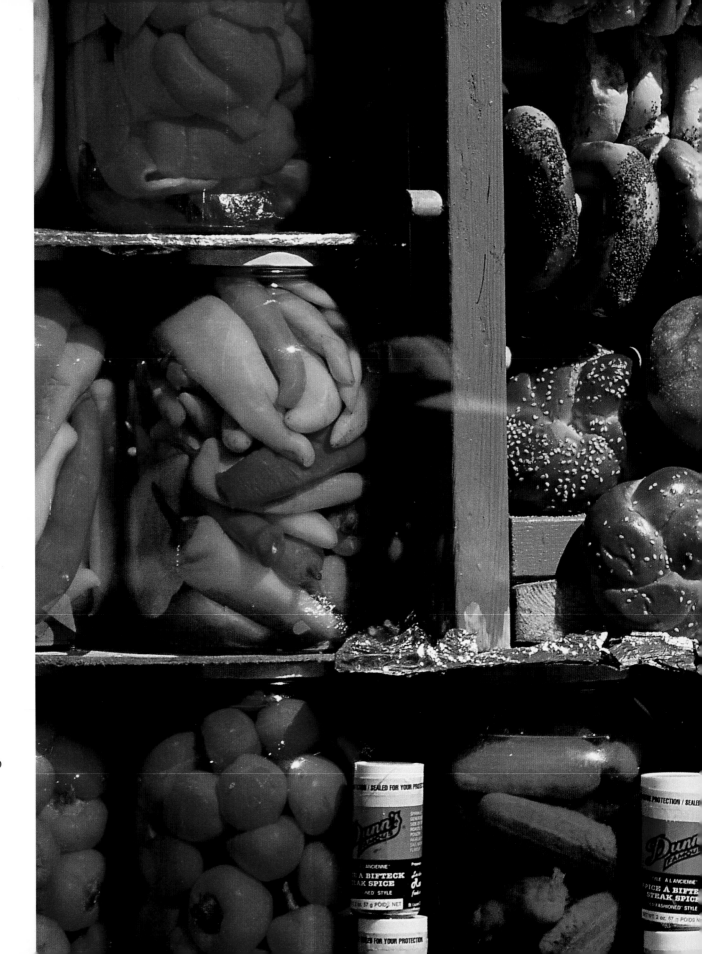

Montreal's delis offer more than just appealing window displays. Most visitors seek one out to try gigantic smoked meat sandwiches, a local specialty.

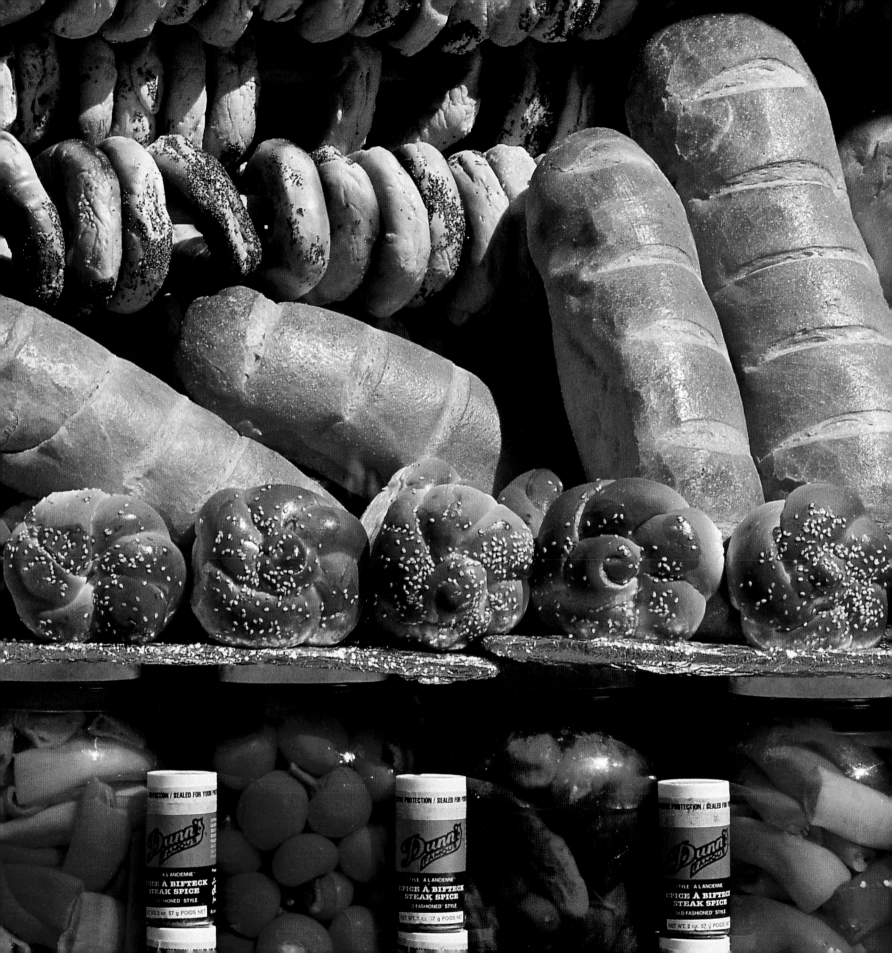

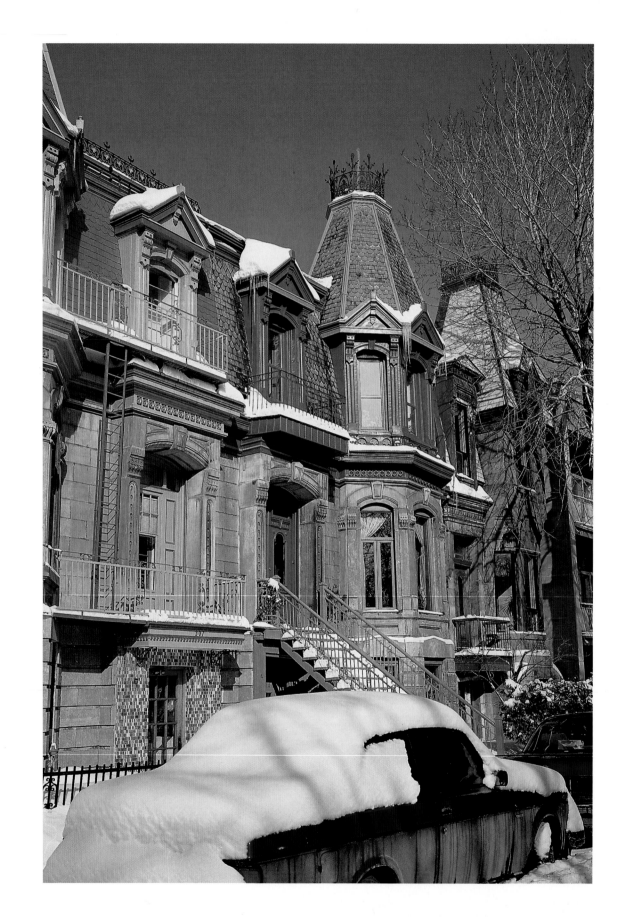

Some sightseers bypass Montreal's museums and galleries in favour of walks through the unique neighbourhoods that surround the city.

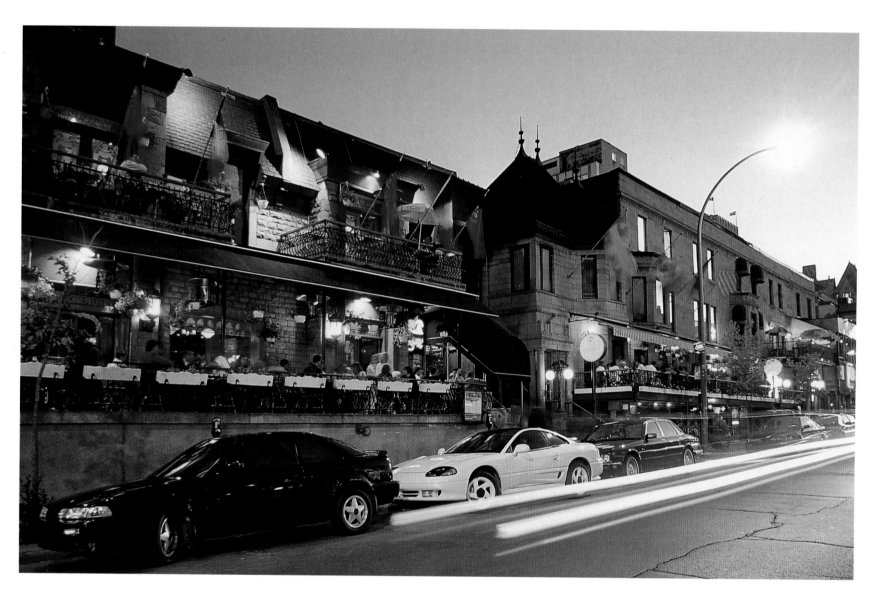

Crescent Street is a hot spot of Montreal nightlife, but even in the afternoons its shops and restaurants are always busy.

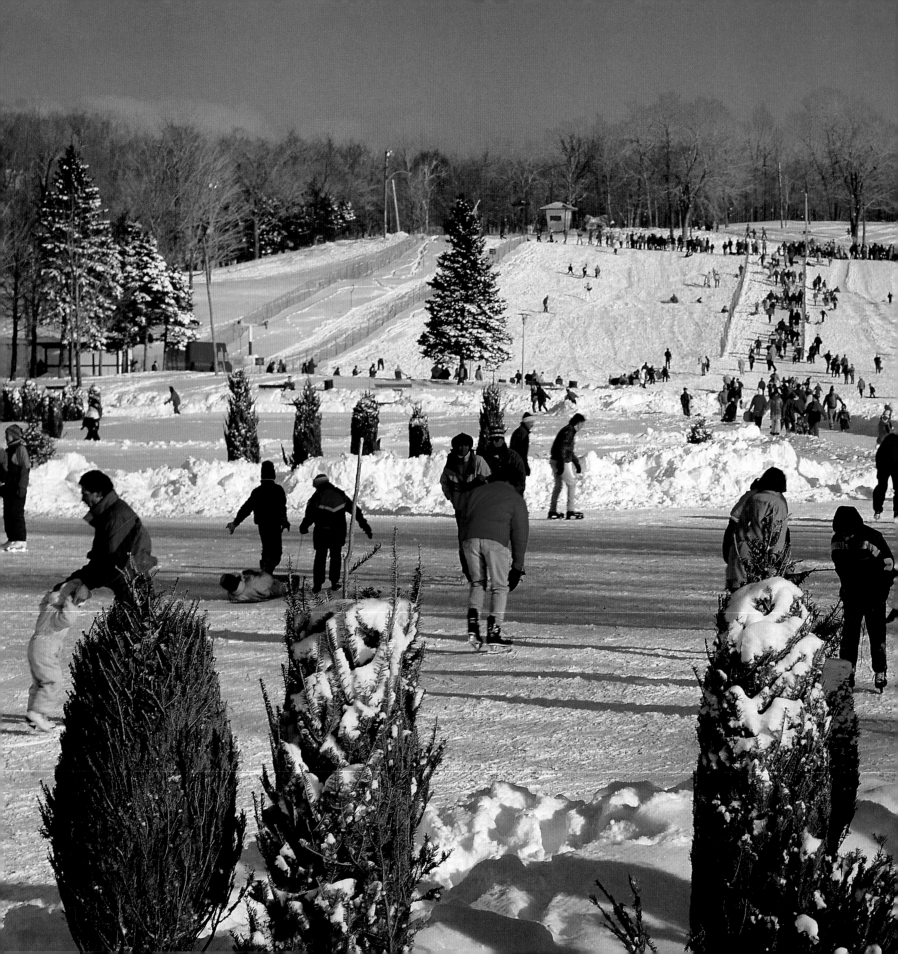

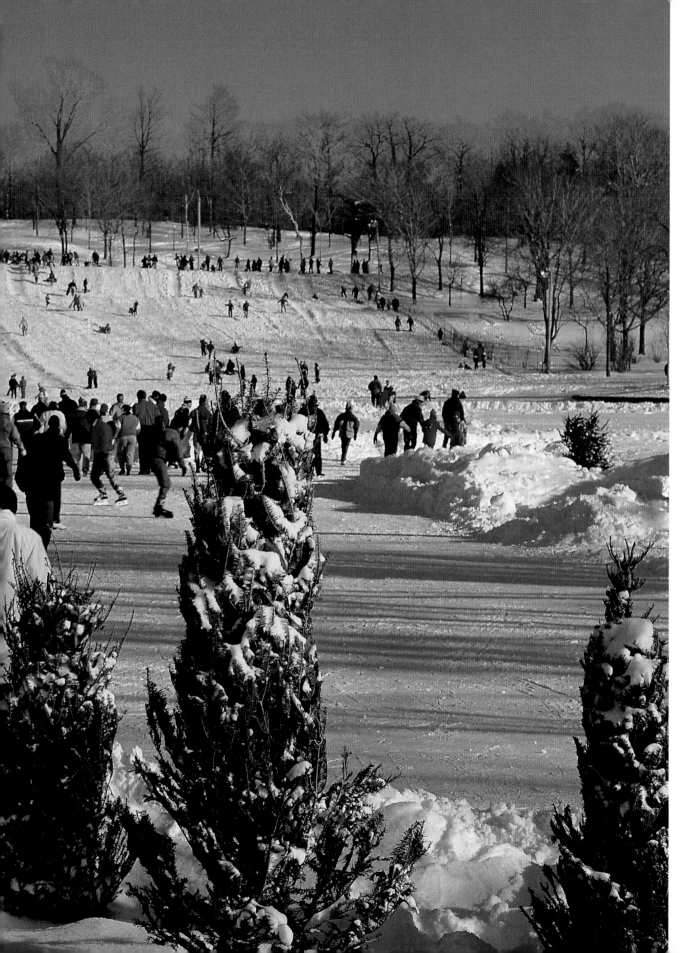

Skating is a favourite
winter pastime.
There are often
crowds on the ice of
the St. Lawrence or
on Lac des Castors in
Mount Royal Park.

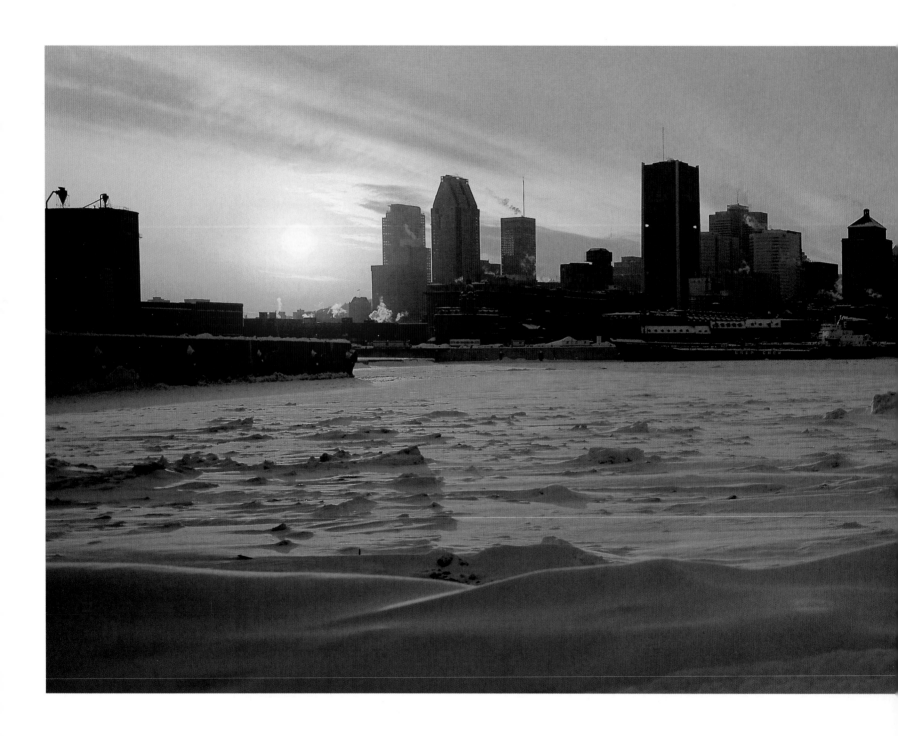

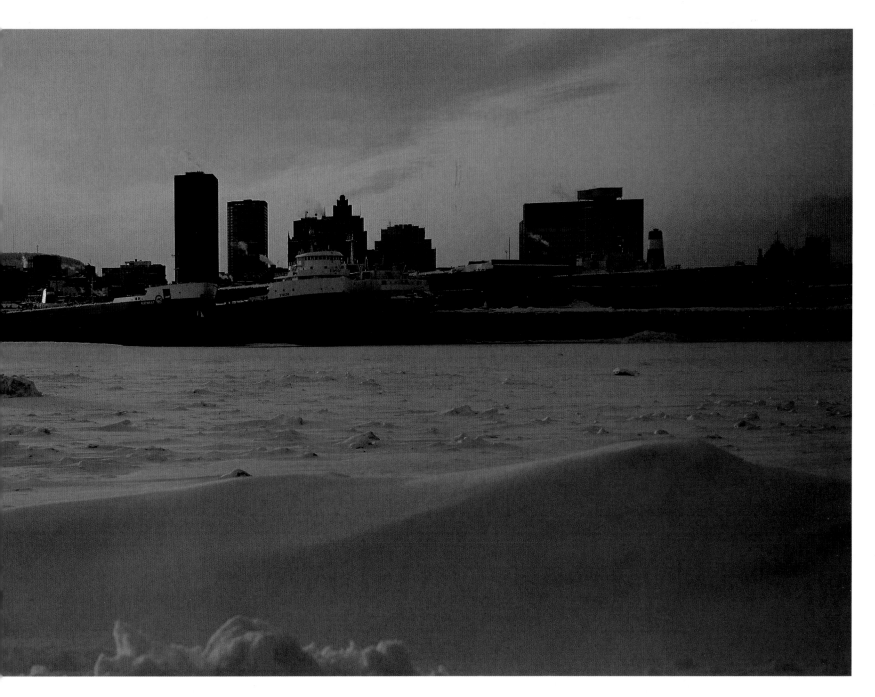

The winter sun glistens off the ice- and snow-cloaked port.

Photo Credits

G. FONTAINE/PUBLIPHOTO i, iii, 70–71, 74–75, 78–79

THOMAS KITCHIN/FIRST LIGHT 6–7, 9, 12, 14, 34–35, 39, 80–81

KEN STRAITON/FIRST LIGHT 8, 21, 30, 31, 64–65, 67, 69, 83, 84–85

CLAUDE RODRIGUEZ/PUBLIPHOTO 10–11, 94–95

RON WATTS/FIRST LIGHT 13, 24, 28, 29, 53, 88–89

ALAN MARSH/FIRST LIGHT 15, 18, 19, 20, 22–23, 36–37, 38, 47, 48–49, 50, 54–55, 56, 66, 79, 86–87

J.C. HURNI/PUBLIPHOTO 16–17

Y. MARCOUX/PUBLIPHOTO 25

YVES BEAULIEU/PUBLIPHOTO 26–27, 91

PAUL G. ADAM/PUBLIPHOTO 32–33, 42–43, 68

CHRIS CHEADLE/FIRST LIGHT 35, 40–41, 46, 51, 60–61, 62

G. ZIMBEL/PUBLIPHOTO 42, 45, 63

J.P. DANVOYE/PUBLIPHOTO 44, 87

IMAGE ACTUELLE/PUBLIPHOTO 52, 82

DEROME/PUBLIPHOTO 57

STEPHEN HOMER/FIRST LIGHT 58

PIERRE BRUNET/PUBLIPHOTO 59

P. LOGWIN/PUBLIPHOTO 72

GUY SCHIELE/PUBLIPHOTO 73

M. BERGER/PUBLIPHOTO 76

M. TREMBLAY/PUBLIPHOTO 77, 92–93

Y. HAMEL/PUBLIPHOTO 90